IMAGES
of America

ORCAS ISLAND

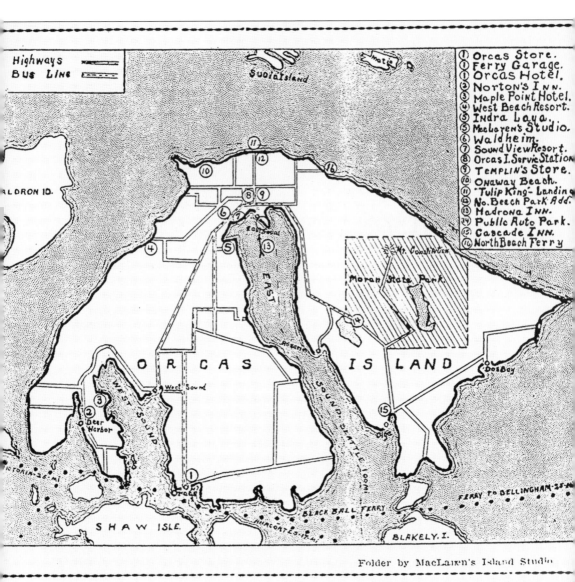

Highways
Bus Line

1 Orcas Store.
1 Ferry Garage.
2 Orcas Hotel.
3 Norton's Inn.
4 Maple Point Hotel.
4 West Beach Resort.
5 Indra Laya.,
5 MacLaren's Studio.
6 Waldheim.
7 Sound View Resort.
8 Orcas I. Service Station.
9 Templin's Store.
10 Onaway Beach.
11 "Tulip King"-Landing
12 No. Beach Park Add.
13 Madrona Inn.
14 Public Auto Park.
15 Cascade Inn.
16 North Beach Ferry

SUCIA ISLAND

WALDRON ID.

ORCAS ISLAND

Moran State Park.

Mt. Constitution.

EAST SOUND

WEST SOUND

Deer Harbor

West Sound

Dos Bay

Rosario

SEATTLE 100 MI.

VICTORIA 35 MI.

Olga

Orcas

SHAW ISLE.

ANACORTES 17 MI.

BLACK BALL FERRY

BLAKELY I.

FERRY TO BELLINGHAM 25 MI.

Folder by MacLaren's Island Studio

This map of Orcas Island was published in 1941, when resorts were the mainstay of the island economy. Fifteen different resorts, at separate locations around the island, were noted on the map. During their heyday, island resorts employed a large segment of the Orcas Island population.

ON THE COVER: The Orcas Island ferry landing awaits an approaching Washington State ferry in this photograph taken before 1949. Originally built to service visiting steamboats with wood and water, the dock at Orcas Landing became the sole island ferry dock after Washington State took control of the ferry system in 1938.

IMAGES
of America
ORCAS ISLAND

The Orcas Island Historical Society and Museum

ARCADIA
PUBLISHING

Published by Arcadia Publishing
Charleston, South Carolina

Printed in the United States of America

Library of Congress Catalog Card Number: 2005936022

For all general information contact Arcadia Publishing at:
Telephone 843-853-2070
Fax 843-853-0044
E-mail sales@arcadiapublishing.com
For customer service and orders:
Toll-Free 1-888-313-2665

Visit us on the Internet at www.arcadiapublishing.com

CONTENTS

Acknowledgments 6

Introduction 7

1. First Residents and Early Homesteaders 9

2. Early Settlements 21

3. Farming and Industry 39

4. Steamship Routes and Wagon Roads 61

5. Resorts 75

6. Schools and Social Life 85

7. Robert Moran, Rosario, and Moran State Park 103

8. The Modern Era 119

Bibliography 127

ACKNOWLEDGMENTS

Since the Orcas Island Historical Society and Museum was founded in 1951, dozens of volunteers have contributed thousands of hours to preserve the unique history of our wonderful island home. With the invaluable assistance of Jane Barfoot-Hodde, Fred and Peg Nicol, Virginia Jensen, Richard Schneider, and Bud McBride, and the museum book committee of Jen Vollmer, curator and director, and Barry Madan, trustee and treasurer, Tom Welch has researched and written this book in an effort to acquaint others with the wonderful history of Orcas Island, Washington.

INTRODUCTION

Orcas Island lies in the Salish Sea, north of Puget Sound, midway between the Washington mainland and Vancouver Island, Canada. The largest of the 172 islands in San Juan County, Washington, the unique shape of Orcas Island contains 57 square miles of hilly, forested land bounded within 125 miles of mostly rocky shoreline. Home to the Northern Straits Salish, including the Lummi, Samish, Saanich, Semiahmoo, and Songhee tribes, Orcas Island was populated by First Peoples for countless generations before its discovery by white men in the late 18th century. Orcas Island provided its original inhabitants with a bountiful larder of food from sea and land in a sheltered, protected environment.

Spanish explorers named Orcas Island in honor of the viceroy of Mexico, a gentleman with 13 names, one of which was Orcasitees. Capt. George Vancouver, on his epic voyage of discovery in 1792, sailed along the eastern shore of Orcas Island. Charles Wilkes, commanding the United States exploring expedition in 1839–1842, mapped the islands and waters surrounding Orcas Island and named Mount Constitution, at 2,409 feet, the highest point in the county. The first white settlers on Orcas Island were two men originally sent by the Hudson's Bay Company at Fort Victoria on Vancouver Island, to hunt deer on the island. Liking what they saw as they hiked and hunted over the island, the two men left the Hudson's Bay Company employ, built cabins, and settled on Orcas Island.

Settlement grew slowly for many reasons, chief among them a boundary dispute with Great Britain that questioned sovereignty over the islands and caused great hardship to homesteaders unable to "prove up," or patent, their claims. Miners traveling from California to new goldfields in Canada and Alaska passed through the islands and some stayed behind to settle on the island. Recalling the mild climate and pristine forests of the island and remembering the waters teeming with salmon, others returned from their gold rush adventures to settle on homestead claims. New white settlers lived harmoniously with the First Peoples, and many married native women and started families.

The decades following the Civil War saw increased settlement on Orcas Island. Olga, Deer Harbor, West Sound, Newhall, and Eastsound, at widely scattered points around the island, became the first population centers. Built around docks and early post offices, the small, isolated settlements slowly added schools and small businesses to the crude log cabins and rustic frame buildings housing the workers and their families. As the government authorized new post offices, mail routes arose that required a certain frequency and dependability; these, in turn, stimulated trade in both passengers and freight, and the islands established commerce with mainland points.

Commercial activity was slow to come to Orcas Island, owing to the difficulty of transport, the sparse and scattered population, the low level of economic activity centered for the most part on trade and barter, and the unsettled frontier. The Langdon Lime Kiln was the first commercial enterprise on Orcas Island, and other limekilns were soon constructed to take advantage of the limestone outcroppings found at different locations on the island. The limekilns produced

lime for building and construction by heating the rock over wood fires, which consumed vast quantities of wood. Fish traps, built atop known salmon migration routes, netted millions of fish, and canneries were built nearby to process the salmon for shipment to distant markets. Sawmills were built to provide box and barrel stock to pack the lime and fish, finished lumber for houses and buildings, and timbers for construction of docks, piers, and fish traps. Andrew Newhall bought the steamer *Buckeye*, secured a mail route contract and a post office for the community at Newhall, and began providing competition to the existing steamship monopoly.

Steamships began stopping at the small, remote settlements around Orcas Island with increasing frequency on the various mail runs to the island. Commercial traffic grew as powdered lime from the limekilns, fruit, wool, and salmon were shipped to mainland markets. A large fruit-growing business started near Eastsound and other islanders soon joined in planting orchards of various types, settling eventually on Italian prunes as the commercial crop best suited to the island soil and climate. Other common crops included apples, pears, strawberries, rhubarb, peaches, apricots, and cherries. By the late 1890s, Eastsound resembled an orchard more than a community, with rows of fruit trees planted wherever the settlers could find space to put them.

Passenger traffic increased through the last decades of the 19th century, with "excursions" from Seattle and other cities growing in popularity. The East Sound Inn, Our House, and other small hotels began providing facilities for visitors, and a few small resorts arose at scattered locations, providing "tent camping" facilities for vacationers who wanted to stay on the island. In the 1890s, it wasn't unusual to see several hundred people disembark from excursion steamships at the Eastsound docks on a Sunday morning and scatter over the island for hours of hiking, sightseeing, and beachcombing.

"Boom and bust" economic cycles affected Orcas Island as they did everyone else, but the effects were eased by the mild climate, ready supply of timber for firewood and building, plentiful bounty of salmon and other seafood near at hand, and the ability of islanders to grow just about anything they desired. The Orcas Island fruit business stimulated steamship traffic, with voluminous shipments of prunes, apples, and other fruit requiring three daily steamship sailings from Eastsound. More than 160,000 boxes of apples were shipped from Eastsound docks in 1895, and thousands of barrels of Italian prunes were shipped fresh by rail as far east as Omaha, Nebraska.

The Orcas Island fruit business was in precipitous decline by 1915, due in part to the improved methods of irrigation and better proximity to rail of the orchards in eastern Washington. As the orchards fell into disuse, however, the resort and tourism business began to increase as more people on the mainland became aware of the pastoral beauty, wonderful fishing and hunting, and incredible marine vistas found on Orcas Island. The resort industry had its origins with the start of Norton's Inn in Deer Harbor, the first island resort to offer platform tents, a dining room, and other amenities to paying guests.

Resorts became the primary business on Orcas Island during the first decades of the 20th century, with more than 25 operating at their peak, providing employment for island residents and guest workers. Tourists and vacationers returned annually to stay at favorite lodges and inns, shop in the local markets, and try their hand at fishing on charter boats. They quickly became the driving force in the local economy. Modern amenities, including telephone service, a dependable supply of electrical power, paved roads, scheduled daily ferries, and the first commuter airline on the West Coast enhanced the natural attractions of Orcas Island for both residents and tourists alike.

Orcas Island today mirrors the many changes society has undergone in the years leading up to the new century. Fast, reliable travel by air and sea gives thousands of annual visitors and seasonal residents easy access to the scenic attractions nature has bestowed on our wonderful island home. Modern photography, television, the Internet, and other media access has spread images of our incredible views and panoramas throughout the world, bringing visitors from many nations to Orcas Island to experience for themselves the beauty of our natural surroundings.

One

FIRST RESIDENTS AND EARLY HOMESTEADERS

Over 9,000 years of human occupation is represented in the shell middens, clam farms, stone tools, reef net anchors, and other artifacts found scattered around Orcas Island. The first residents, today known as the Northern Straits Salish, including the Lummi, Samish, Saaanich, Songhee, and Semiahmoo nations, lived in scattered, often seasonal settlements of family groupings at different locations around the island. Their cedar plank houses were built on the beaches where food was accessible and their cedar dugout canoes could be easily launched for hunting and fishing, visits to neighboring tribes, or to protect their territory and resources.

After the Hudson's Bay Company founded Fort Victoria on Vancouver Island in 1843, attacks by more warlike Northern Indians, including the Haida, Skeena, Bella Bella, and Tlinglit, wreaked havoc among the more peaceful natives living on Orcas Island. Local natives kept careful watch for raiding parties, sounding the alarm and scattering into the forests when their giant war canoes, often containing more than 40 warriors, approached the island beaches. With firearms obtained from Russian and other traders to the north, the Northern Indians overpowered the local natives, killing or enslaving everyone they found.

The first white settlers on Orcas Island were Hudson's Bay men, who had hunted deer for the Fort Victoria outpost in the early 1850s. Smallpox brought by fur traders had, by that time, combined with depredations of the raiding Northern Indians to drastically reduce the native population, and the first white settlers found few natives living on the island. Other white men, traveling through the islands en route to the Fraser River goldfields, returned from their gold rush adventures to settle at various locations on the quiet, pristine island. Many early settlers married native women, built cabins, and carved homesteads out of the dense forests that covered most of the island.

More settlers arrived in the 1860s and 1870s and enjoyed a quiet, peaceful existence on the remote island, far from the Civil War and resulting Reconstruction that was consuming the rest of the United States. More and more white women accompanied the new homesteaders, and settlers and natives alike lived a mostly harmonious existence together until discriminatory social practices began to inject prejudice into island life.

The families created through the marriage of white settler men and native women, previously accepted by all, began to experience discrimination and prejudice directed at the native and mixed-race family members. The traditional marriages between the white men and native women were not recognized by the legal authorities. Men with Indian wives were forced to undergo legal marriages and adopt their own children. A sad chapter had opened, one in which children denied their own mothers, and fathers their own children, as all strove for acceptance in the new white society.

Toleration and welcoming acceptance are natural traits of pioneer people, and life on Orcas Island gradually grew to include a better understanding and appreciation for the Indians, whose ancestors were the original inhabitants. Islanders today are proud to be living on an island paradise protected for so long by the natural stewardship of precious resources exhibited by the first residents over thousands of years of occupation, and are eager to promote similar values today.

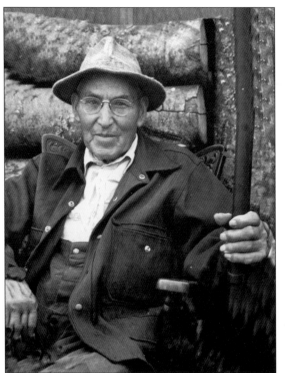

The son of the first white settler in the Deer Harbor area, Louis Cayou, and his wife, Mary Ann, a native of Lummi and Saanich descent, Henry Cayou was an important person in San Juan County for many years. County commissioner for 27 years, owner of the first fish trap built in Washington waters, and reputed to have caught over five million salmon in his lifetime, Cayou was a major figure in the Washington State fish industry. His mother married his father, gave birth to Henry at the age of 14, and bore eight more children with him at their homestead in Deer Harbor before his father passed away. She later married Pe Ell, head fisherman of the Mitchell Bay Band of First Peoples, who Henry later credited with teaching him all he knew about salmon fishing.

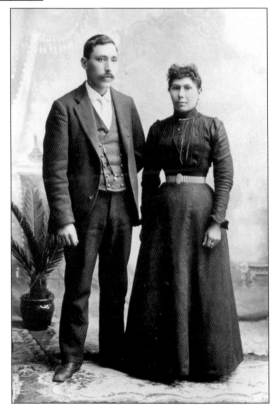

Henry Cayou and his first wife, Mary Reed Cayou, appear to be a prosperous couple in this photograph taken sometime before her death in 1912.

Frank Shattuck was the son of Charles Shattuck and Jeannie, his wife, a Coast Salish woman. Charles Shattuck was the first settler in Eastsound, had the first store and post office at that location, and was one of the first white men on Orcas Island. When Frank Shattuck wrote his family history for an article in the local newspaper in 1944, he acknowledged everyone in his family except his mother.

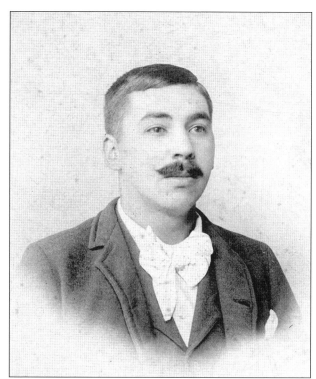

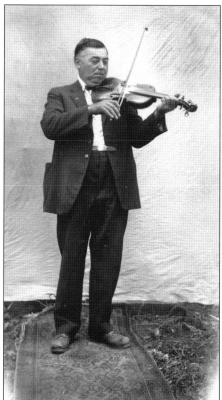

Son of Charles Shattuck and Jeannie, a Coast Salish woman, Frank Shattuck was an accomplished violinist well known on Orcas Island in later years for telephoning friends and playing song after song on the violin. Shattuck poses with his instrument in this September 1923 photograph.

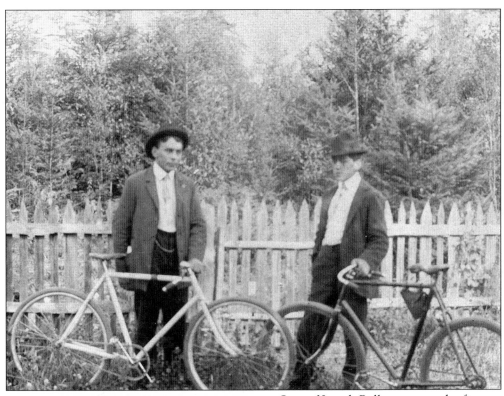

Sons of Joseph Bull, a trapper who first came to Orcas Island sometime before 1860 and was later buried at Madrona Point, Alfred and Bob Bull pose with their bicycles.

Michael Adams, a trapper and gold hunter originally from Pennsylvania, was one of the first white settlers in Eastsound. He first arrived on Orcas Island in 1858 and settled permanently in the Eastsound area in 1865. An accomplished horticulturalist, Adams planted the first apple orchard on the island.

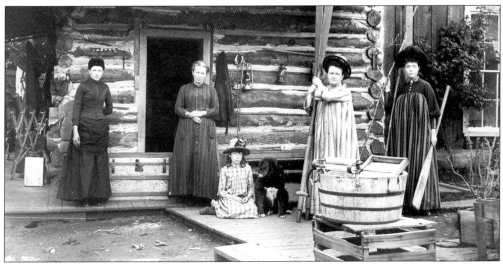

The Fry family women pose in front of their log cabin in this photograph from 1890. John N. Fry and his wife, Sarah Jane, were among the earliest settlers in Eastsound. Mrs. Fry was known for her kindness and hospitality; she invited newcomers to come and stay with them until they were settled on their own places.

Jennie Viereck, married to John Viereck, the first white settler in Doe Bay, started life in the Metlakatla nation on the northern British Columbia coast in 1845. With Viereck (who had abandoned ship in her area) since she was 13 years old, she had 13 children, 6 of whom were born on Orcas Island. John and Jennie Viereck came to Orcas Island in 1872 and applied for homestead status, which was awarded in 1879. State law required that Jennie and John be remarried in 1872, and John had to recognize and claim each of their children in order to give them legal status in the eyes of the state. Jennie Viereck died in 1898 at the age of 50, well beloved by all who knew her. Her obituary in the April 21, 1898, *San Juan Islander* speaks eloquently of both her life and of the times: "There, amid the hardships of pioneer life she dedicated herself to her family and God. She was an Indian, but that she had a heart as kindly beats in any woman's breast no person who knew her could doubt for a moment." The article concluded with, "she was a good woman and a faithful, patient wife and kind and loving mother admired and respected by all who knew her and was always ready to assist and comfort. Those in her large circle have lost a true friend."

The daughter of John and Sarah Jane Fry, early homesteaders in East Sound, Jenny May Fry poses for a studio photograph in Seattle in the 1890s.

John Peter Legbandt arrived on Orcas Island in 1881 and settled near his brother Peter in Doe Bay. In 1883, his wife, Anna, and daughter Katrina came from their native Denmark and joined him. Katrina Legbandt was the first white child in Doe Bay. Pictured in front of their log cabin in 1890, from left to right, are Klaus, Anna, William, Katrina, John, and Emma Legbandt.

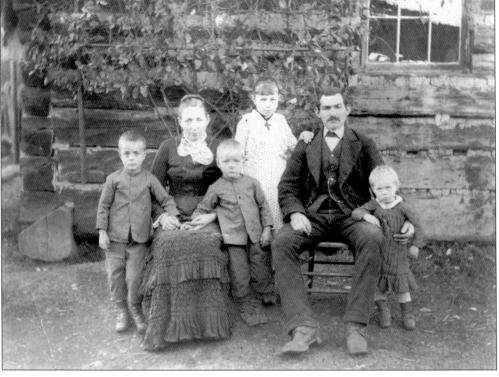

Ephraim Langell arrived on Orcas Island about 1870, having first seen the island in 1860 while on his way to the Fraser River gold rush. Langell, originally from Nova Scotia, was the father of Belle Langell, the first white child born on the island. He and his wife Rosa homesteaded near Michael Adams in Eastsound.

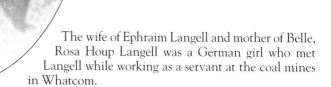

The wife of Ephraim Langell and mother of Belle, Rosa Houp Langell was a German girl who met Langell while working as a servant at the coal mines in Whatcom.

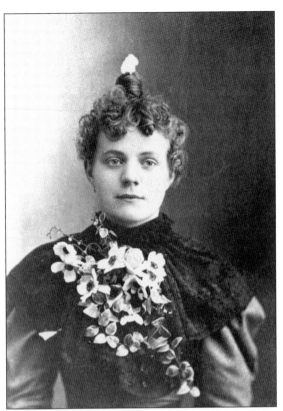

Belle Langell, daughter of Ephraim and Rosa Langell, was the first white child born on Orcas Island.

John and Rachel Boede came to Orcas Island in 1884, built a one-room log cabin with a sleeping loft, and raised nine children in it. The cabin has been relocated and restored and serves today as one of the six original homestead cabins that make up the Orcas Island Historical Museum. The family members, from left to right, are (first row) Henry, Rachel, Echart, John, and William; (second row) Iona, Fred, Pearl, John, Bertha, and Conrad. John Boede settled in the Orcas area, purchased a fruit ranch from George Myers in 1919, and operated it commercially until 1940.

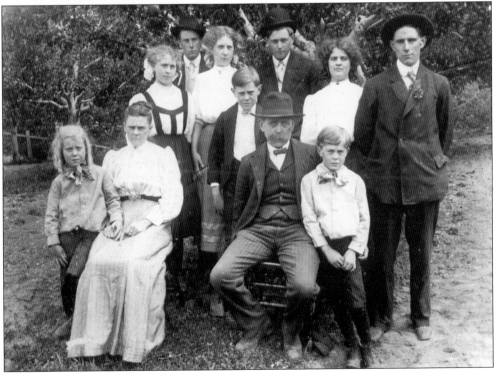

Andrew Nordstrom was an early settler who helped John Boede build his log cabin. Nordstrom Lane in Crow Valley was named for Andrew Nordstrom.

Mr. and Mrs. Charlie Stowers sit on their porch steps while Allie and Fred Geoghagan stand nearby in this photograph taken sometime before 1890. The Stowers home reflects the early days of prosperity on Orcas Island.

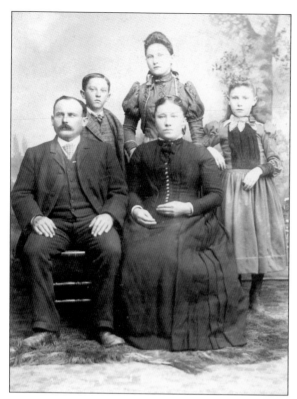

The Rilling family poses for a picture, sometime in the 1890s. Along with Pat Langell, Charley (standing behind his father, Robert) was the first to drive an automobile to the summit of Mount Constitution in 1912, in his 1910 Model T. Louise and Katherine, Charley's sisters, are standing behind their mother.

The well-dressed Kepler family poses in this rather formal picture taken on July 5, 1891.

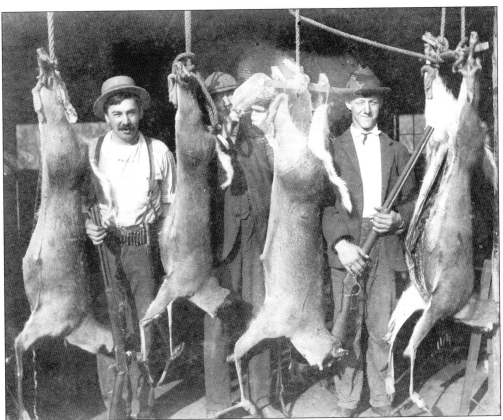

Pictured, from left to right, are Frank Shattuck, Lute Sutherland, and Wes Langell with the deer they have taken after a typical day's hunt on Orcas Island. There were no predators larger than a raccoon on the island, and the deer enjoyed the grass and other forage available year round in the island's mild climate.

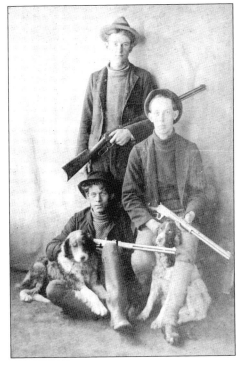

Ready to hunt with their dogs, from left to right, are Pat Langell, George Whiteley, and Walt Stowers.

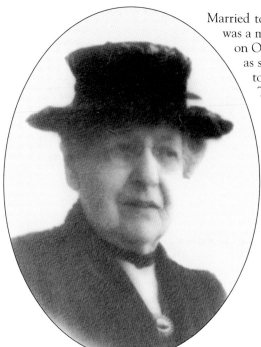

Married to Dr. I. M. Harrison, Dr. Agnes B. Harrison was a medical doctor herself who practiced medicine on Orcas Island for many years. Mrs. Dr. Harrison, as she was called, was known for her willingness to respond, in any weather, to a call for help. The Drs. Harrison purchased Madrona Point in 1894 and moved permanently to the island in 1907. The Harrisons had three children, one of whom (Joseph) later became the only Rhodes Scholar produced by Orcas Island. Mrs. Dr. Harrison practiced medicine, started a successful store in Eastsound, and founded the Madrona Inn during her long years on the island. Agnes B. Harrison was born in 1860 and died in 1949 at the age of 89.

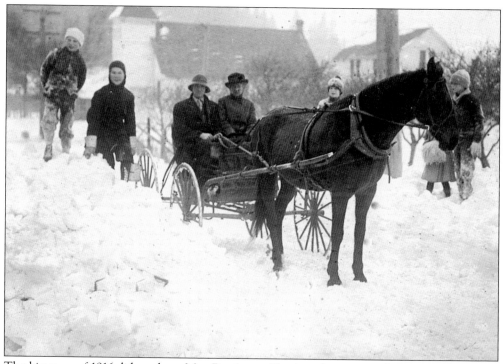

The big snow of 1916 did not keep Mrs. Dr. Agnes Harrison from responding to a call for help. Reverend Eastman drives the buggy while Mrs. Dr. Harrison rides along during a house call after the rare snowfall.

Two

EARLY SETTLEMENTS

The settlements developed on Orcas Island after the 1850s were small collections of log cabins (sometimes known as "houses" because they were made of sawn logs) constructed at widely scattered locations along the shore. The hilly, forested island terrain, completely devoid of roads, made travel a difficult challenge in those early days. It was far easier to sail or row a boat, or paddle a canoe, than it was to walk over the rough island trails and paths.

The first white men found employment as the earliest commercial enterprises—lime kilns, fish traps, and sawmills—were built and began to grow, each taking advantage of the rich resources of the island and surrounding sea. The small settlements grew as docks and post offices were slowly added to the growing number of homes in each little community.

Some early settlements on Orcas Island, such as Ocean on the west shore and Dolphin Bay on the west side of Eastsound, blossomed quickly and faded into oblivion nearly as fast, leaving little trace of their existence today. Newhall was a thriving community built around Andrew Newhall's sawmill and boatyard at Cascade Bay. Sold to Robert Moran in 1905, it is now the location of the world-famous Rosario resort.

Deer Harbor was settled in the late 1850s when Louis Cayou and James Bradshaw married native women and built homes there after several years spent hunting deer in the area for the Hudson's Bay Company outpost in Victoria. Eastsound had its origins with Charles Shattuck claiming a homestead at the head of East Sound Bay in the 1850s. The community of West Sound began when trappers, including Joe Bull, began settling homesteads in the area in the 1860s.

Olga was settled in 1860 when William Moore, another former Hudson's Bay deer hunter, homesteaded a claim there. Doe Bay was first settled when John Viereck, a German sailor who had "jumped ship" on the northern coast some years earlier, settled there with his wife, Jennie, in 1872. Henry Legbandt, another German, and Peter Morris, a French-Canadian, were the other early settlers at Doe Bay, both arriving shortly after Viereck.

The community of Orcas was originally known as Orcas Island, but changed in 1898 to Orcas. In the 1860s, Paul K. Hubbs had a store east of Orcas at Grindstone Bay, so called because he had the only grindstone on the island. In 1885, W. E. Sutherland opened a store at Orcas, built a dock to handle boat traffic, and began providing wood and water to the growing number of steamboats plying the islands.

Hugh Templin's dock stretches into East Sound near Indian Island as a steamship gingerly approaches. Shallow water between the small island and the Eastsound shore required a very long dock to permit heavily laden ships carrying passengers and supplies to dock safely without fear of grounding at low tide.

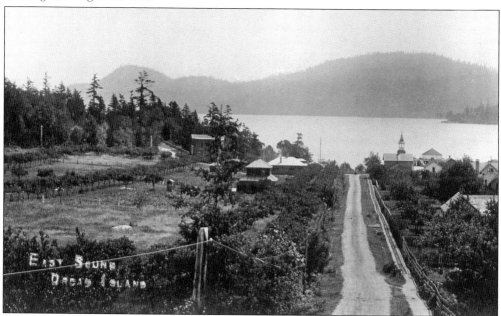

In this image, looking south toward East Sound Bay, the village of Eastsound lies astride a well-traveled North Beach Road. The steeple of the Methodist Episcopal church towers over the growing community, with Mount Woolard in the distance across the bay. The Episcopal and Methodist Episcopal churches dominated the social life of the community as hotels, inns, and other enterprises were slowly added to the commercial center of Orcas Island life.

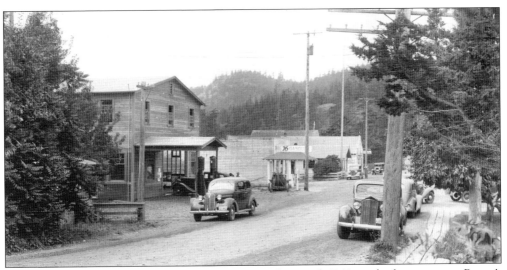

This view looks west on Main Street in Eastsound around 1940, with the two-story Porter's Station in the foreground. Glen Porter, who had worked for Robert Moran as a machine operator for 30 years, owned and operated this garage and service station.

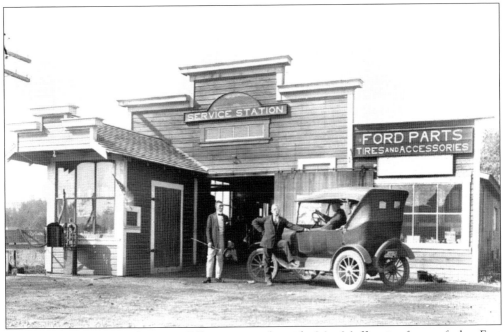

In this 1925 photograph, Mr. Wilkinson stands with Mr. Moffitt in front of the East Sound Service Station. Wilkinson later willed the business to Roger Purdue, his longtime assistant, who was known as the unofficial mayor of Eastsound in later years. Purdue was a popular island character, reputedly able to fix anything or, in his words, "If I can't fix it, I'll fix it so nobody can."

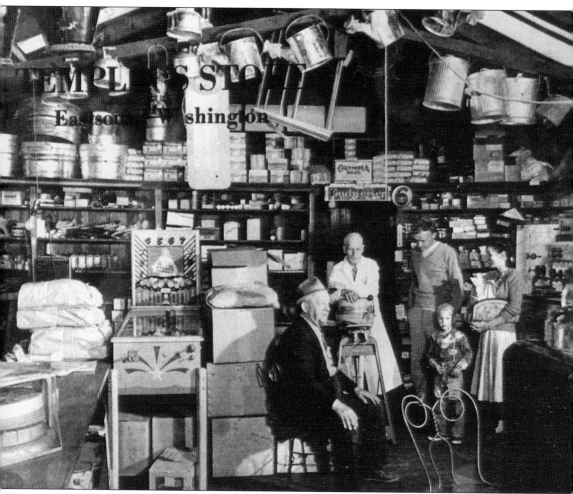

The success of Templin's store was due in part to their willingness to stock almost anything Orcas Islanders needed, as evidenced in this 1949 photograph of the store's interior. Newcomers to the island soon grew accustomed to a fact older residents knew very well—it was a long trip to the mainland if you needed something. Islanders stopped in to shop, trade gossip and visit, inspect new items, or just hang around and pass the time. The store's central location in Eastsound made it a handy place to shop, and most island residents stopped in whenever they came to town.

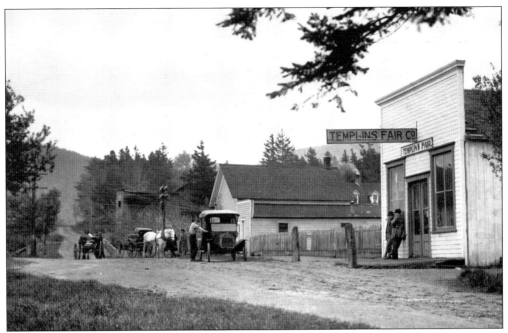

Hugh Wooster Templin relocated from Fairhaven in 1897 and opened Templin's Fair in Eastsound. He later added a dock and warehouse, enlarging the operation considerably to accommodate the growing island businesses.

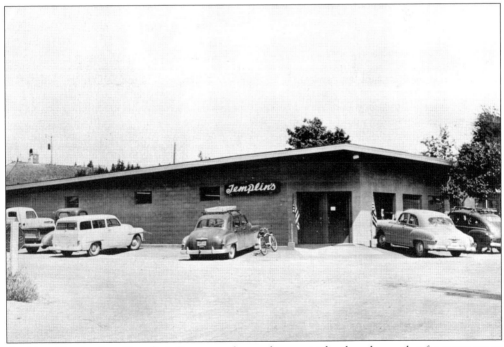

An island institution, Templin's Store was the market most islanders shopped at for many years. Here we see a later incarnation of the store, sometime in the 1950s.

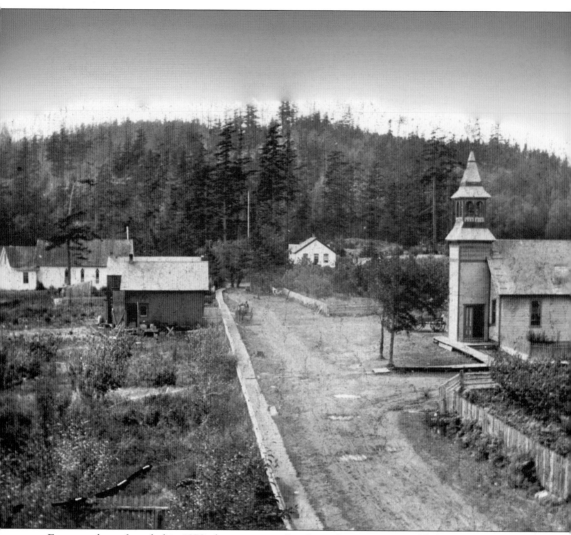

Eastsound was founded in 1873, the same year San Juan County was established by the territorial legislature. Charles Shattuck, the first white settler, built a cabin and operated a store there beginning in the late 1850s. Located at the head of East Sound Bay, the name was later changed to "Eastsound." The commercial center of Orcas Island, Eastsound remains an unincorporated village today.

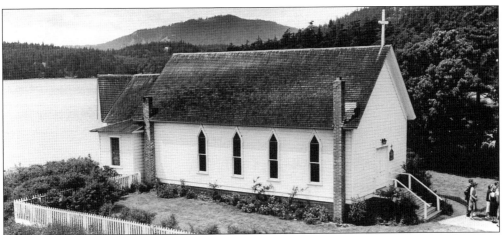

The oldest church on Orcas Island, the Emmanuel Episcopal church was built in 1885 by the Reverend Sidney Robert Spencer Gray on property deeded by Charles Shattuck, the first white settler in Eastsound. Reverend Gray, an Englishman married to the daughter of a German duke, was a visionary, energetic man who organized the congregation, which over time grew to 240 souls. The church became the center of activity for the community. Many island families were baptized, married, worshiped together, and mourned the passing of family, friends, and neighbors at this church. Modeled after the English village churches Reverend Gray fondly recalled from his youth, the Episcopal church remains an integral part of island life today.

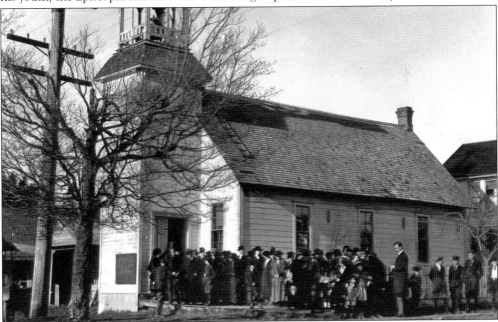

At the direction of Rev. John Alexander Tennant, the Methodist Episcopal church was built by Peter Bostian in 1887 on land donated by Charles Shattuck. Tennant's wife, Clara, was a member of the Lummi tribe from Whatcom County. Reverend Tennant and his wife were well-respected for their tireless efforts, performed that first year for a total compensation of $100, leading him to write to his presiding elder in Seattle that he had better stay on the job, as "any other man with a family would starve to death on that field." Fortunately, he said, he and his wife had gotten used to living on clams, which were free for the taking on nearby beaches.

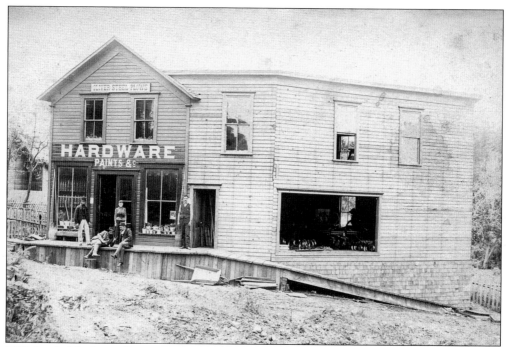

Gillieland's Hardware Store in Eastsound was an early purveyor of rope, nails, wire, and the myriad of other items needed for the growing population of Orcas Island.

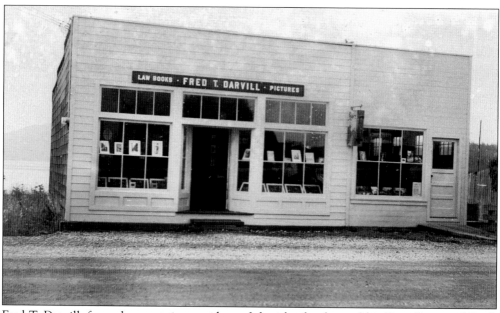

Fred T. Darvill, formerly a part-time resident of the island, relocated his Rare Print and Book Store to Eastsound from San Francisco, opening July 1, 1942, in the building formerly occupied by Lehman's store. He advertised over 150,000 old and rare prints, books, law books, maps, and other publications for sale.

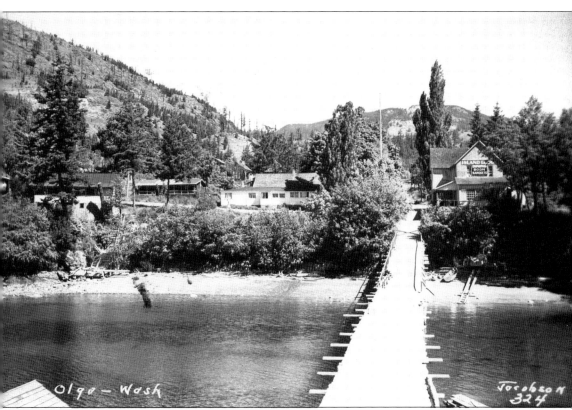

The hamlet of Olga was founded in 1860 shortly after William Moore homesteaded near there. The Olga Post Office, established in 1890, named Hibbard Stone the first postmaster. The first post office was in a log cabin at Buck Bay; it was later moved to the building that housed the first store in Olga. Olga had the first public water supply on Orcas Island and the second school district. Named for the mother of the first storekeeper, John Ohlert, this small hamlet has retained its rustic beauty practically undisturbed for more than 100 years.

Since its earliest days, Doe Bay has had the reputation as a place to enjoy oneself. The remote location of this community, connected in early times only by trail or footpath with the rest of the island, fostered close relations between neighbors that continue to this day.

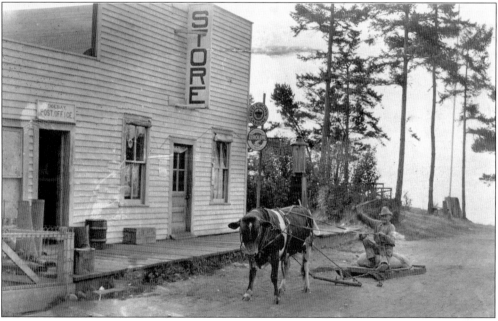

Not every day was a busy one in "downtown" Doe Bay, and traffic was of little concern for this rider and his cow-drawn sled on the street in front of the Doe Bay store. The Doe Bay Post Office was established in 1881 with John Viereck, an early settler, serving as the first postmaster. The post office was originally in the Viereck home.

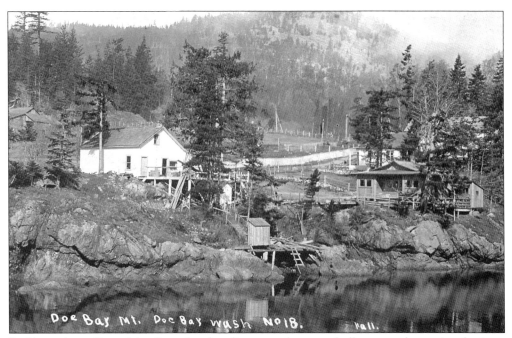

Building along Orcas Island's rocky shoreline was always a challenge, and occasional winter storms eventually battered unsheltered structures to pieces.

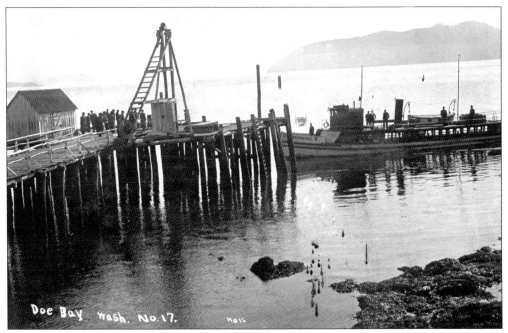

Passengers await an incoming steamship at the Doe Bay dock in this early photograph. The island community closest to Bellingham, Doe Bay was a popular vacation and weekend spot for mainlanders to visit.

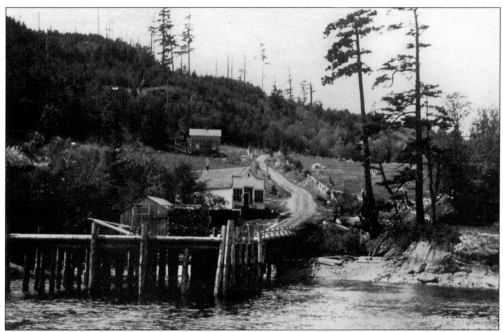

Dolphin Bay, on the west side of East Sound about four miles from the head of the bay, was named for the capped pilings, or dolphins, set near the dock. Originally settled by Freeman Iotte, a French-Canadian trapper, and his family, Dolphin Bay eventually grew to include a store, post office, and school. It was a thriving community in the early 1900s, but little trace remains today.

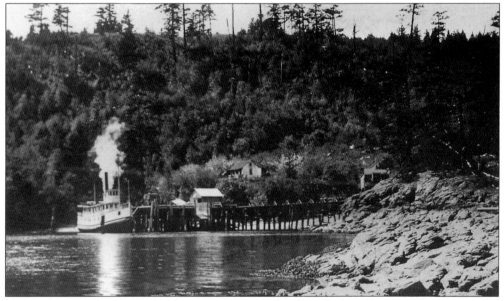

The *Buckeye*, with a head of steam, leaves the Dolphin Bay dock on its itinerary between the widely scattered island communities. The road to the dock, known as Iotte's Landing Road, was used to transport logs from logging operations inland to the water, where they could be rafted before being towed to local sawmills. Steamships delivered mail, supplies, and passengers, stopping frequently to take on cordwood and water.

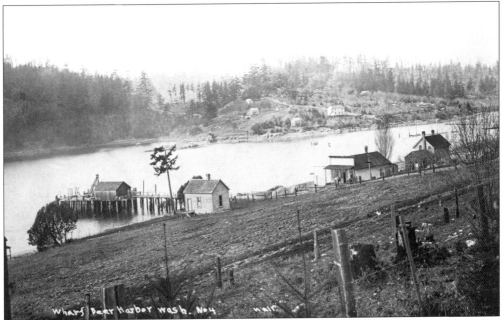

The wharf and J. T. Stroud's store and post office line the eastern shore of Deer Harbor in this early photograph.

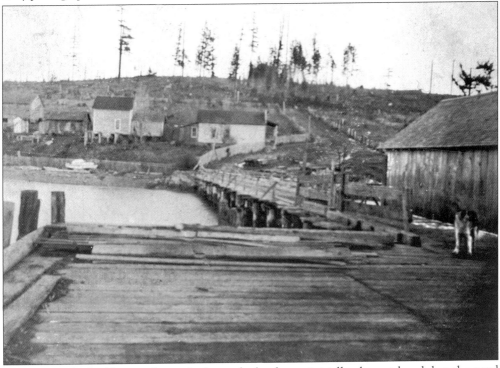

The lumber for buildings, pilings, docks, and wharfs was initially close at hand, but the need for constant supplies of cordwood for homes and visiting steamships soon denuded the nearby hills. A few remaining large trees stand out in the background of this image of Deer Harbor in early days.

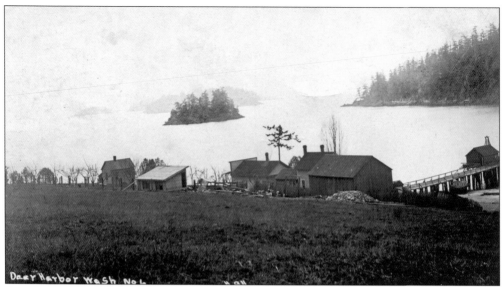

Fawn Island, formerly known as Fisherman's Island for the occupation of two early residents, lies in the background of this image of Deer Harbor. Spring Point is to the right of Fawn Island, with other islands of the San Juan group marching into the distance beyond.

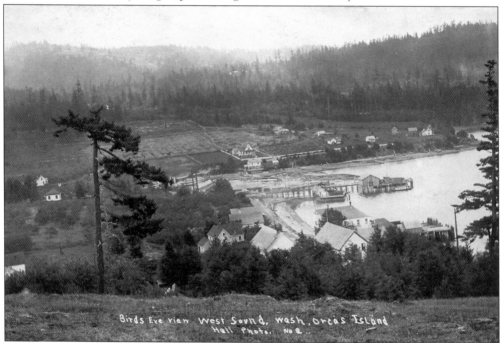

A thriving, prosperous community in its heyday, West Sound had a popular resort hotel, store, post office, and sawmill. An Episcopalian church, built in 1895, had a large congregation for many years. Orchards filled the surrounding fields as the fruit business took hold, and the mills worked long hours to produce the barrel stave stock and boxes needed to ship the bountiful harvests to market. Canneries consumed wooden boxes by the ton as they struggled to ship all the salmon caught in the fish traps in nearby waters, and sawn lumber was in great demand on the mainland.

In 1891, the West Sound store was built by O. H. Smaby, a native of Iowa who was appointed postmaster in 1892. The store later became the island's only cooperative store, known as the Western Trading Company, which continued in operation until 1930.

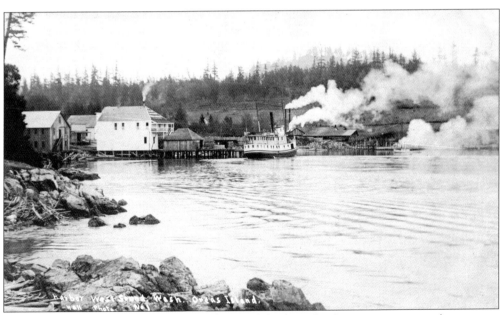

Wood fueled the growth of West Sound, as it did other island communities, supplying steam for ship and sawmill power and cordwood for heating and cooking. As the settlement grew, steamships arrived with greater frequency and more people came to trade and inspect the area. Commerce increased.

Orcas Island was the original name of this settlement on Harney Channel, across from Shaw Island, when it was awarded a post office. Joseph Gibson was the first postmaster at Orcas Island, which in 1898 simply became Orcas. In 1885, W. E. Sutherland built the store and a large dock to serve the steamship traffic.

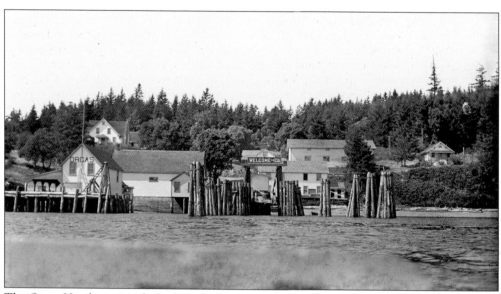

The Orcas Hotel, marine dock, dancehall, store, and post office testify to the busy community Orcas had become after the ferry dock was built and regular, scheduled ferry runs from Anacortes became the island's lifeline. This scene of the Orcas ferry landing and associated cluster of businesses, docks, and pilings is one familiar to a countless number of visitors to the island.

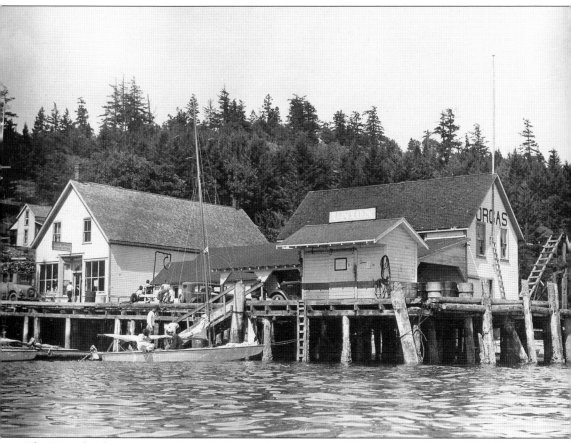

The Orcas landing contained several thriving businesses as well as the post office and fuel dock. The local dance hall was popular with both locals and residents of other settlements and nearby islands and did a thriving business for many years. Pleasure boats stopped to purchase supplies, steamships took on wood and water and delivered mail, passengers, and freight, and later diesel and gasoline-driven craft fueled at the marine dock. The sheltered waters of Harney Channel, between Orcas and Shaw Islands, permitted easier passage when other island settlements were battered by wind and waves. Orcas grew to become the main port of arrival for the island.

Shaw Island is in the background of this image of the Orcas Store and post office] taken from the vantage of the Orcas Hotel.

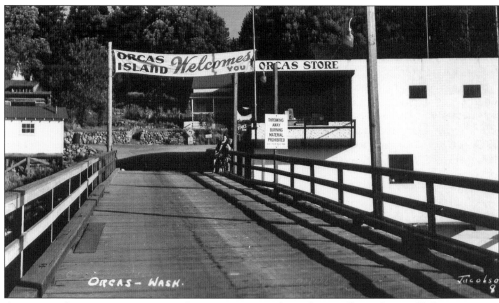

A warm welcome awaits arriving ferry passengers when they walk or drive off the incoming boat, as this image from the end of the ferry ramp shows. Friendly hospitality has always been a hallmark of Orcas Islanders, who are always eager to acquaint visitors with the countless attractions of this island paradise.

Three

FARMING AND INDUSTRY

The earliest commercial enterprise on Orcas Island was Langdon's Lime Kiln, constructed in 1869 on the shores of East Sound where a ledge of limestone rock had been found. Built of stone and brick, limekilns produced lime by heating the limestone rock over wood fires. Island limekilns operated from the 1860s to the 1930s. Lime from Orcas Island and other county lime kilns was an important component of the cement used in the reconstruction of Seattle after the catastrophic fire of 1889 and in the rebuilding of San Francisco after the 1906 earthquake devastated that city.

Fishing, primarily for salmon, was a vital skill for native people from prehistoric times on, and an important island business from the earliest settlement days. Millions of salmon were caught on lines, netted, or trapped in the fish traps erected on known migration routes, and the tremendous catch stimulated the rise of canneries along the shores of Deer Harbor and West Sound. Halibut, cod, rockfish, clams, and oysters were also caught or gathered in abundance and sold in mainland markets.

Sheep were an important island industry from the earliest settlement days, with vast herds roaming the valleys and mountainsides of Orcas Island. There were no large predators on the island, and the flocks ran free and undisturbed except for an occasional improper shearing when ownership was questioned.

Every family had a kitchen garden for food, and farms produced most of an island family's needs. Early settlers found, to their delight, that fruits of all kinds could be grown in the rich soil and mild climate of the island. E. V. Von Gohren came to the island in 1879 and was responsible for the rapid development of the fruit farming industry. He planted the first nursery on the island, which in time grew to over 20,000 young fruit trees of different varieties. It was determined through experimentation that the Italian prune was the commercial fruit best suited to the island soil and climate.

By 1898, the prune trees were bearing so heavily that prune dryers, barn-like structures designed to dry the prunes before shipment, became a necessity. When these were put into operation, a large number of people were given employment. The Red Gravenstein apple made its first appearance in Olga, and growers competed to produce the largest, heaviest, sweetest fruits of all types. Apple barns arose on island farms, and docks were built to accommodate the three daily steamships that transported the shipments of prunes, pears, peaches, apricots, plums, apples, cherries, strawberries, and other fruits, packed in wooden barrels and boxes, to market.

Sawmills produced barrel staves, wooden boxes for packing fruit and fish, and finished lumber for the construction of boats, pilings, docks, and buildings. Logging the dense island forests produced timber that was sold to mainland mills. The Kimple Brick Works produced the bricks, tile, and pipe needed for construction and irrigation.

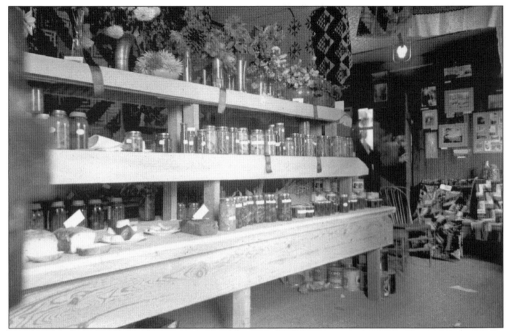

The canning exhibit at the Eastsound Fair is pictured in 1916. Island families competed for bragging rights at the fair, and well-preserved crops of all types drew much attention and praise to the capable canner.

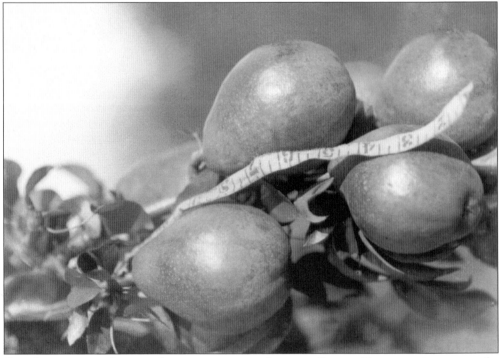

Orandaga pears are shown with a tape measuring their size. County fairs were prime venues for Orcas Island fruit exhibits that often astonished fairgoers with the size, color, and sweetness of the fruits grown on the island.

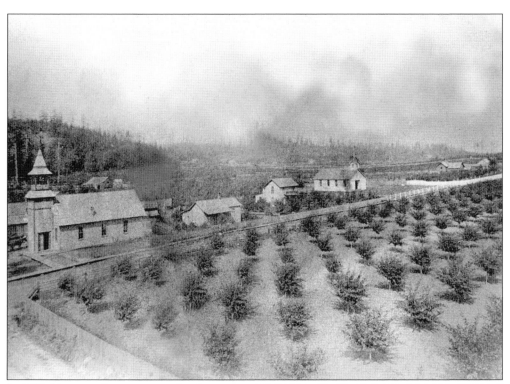

In 1900, Eastsound was more orchard than village, as this photograph of the Methodist Episcopal church, schoolhouse, and other buildings huddled across North Beach Road from an expansive young orchard demonstrates.

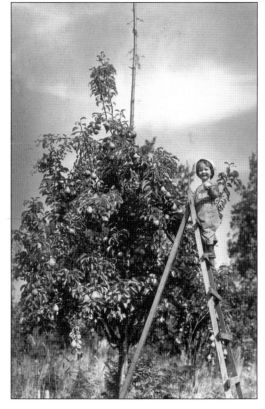

This September 1919 photograph shows Jimmy F. Geoghegan picking Bartlett pears in the family orchard. High atop an orchard ladder, little Jimmy beams with pride as he plucks a ripe pear from this heavily laden tree.

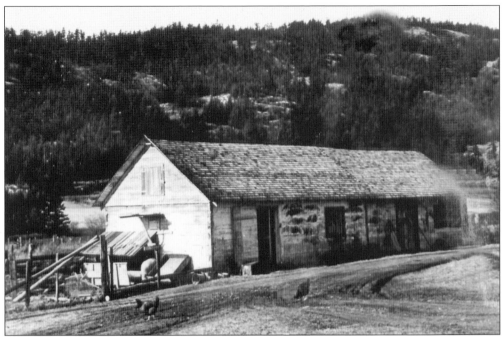

This is an early 1900s image of the Nordstrom's fruit-packing plant at their farm. Fruit had to be sorted, graded, sized, and packed before shipped to markets. The larger farms and orchards built their own plants for convenience in packing and shipping the harvested fruit.

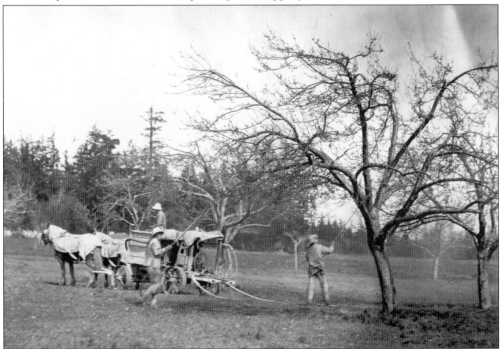

Fruit trees attracted insect pests and preventing infestation was a necessary part of the work of raising crops. In this 1914 photograph of men spraying Mrs. Waldrip's orchard, even the horses wear protective gear.

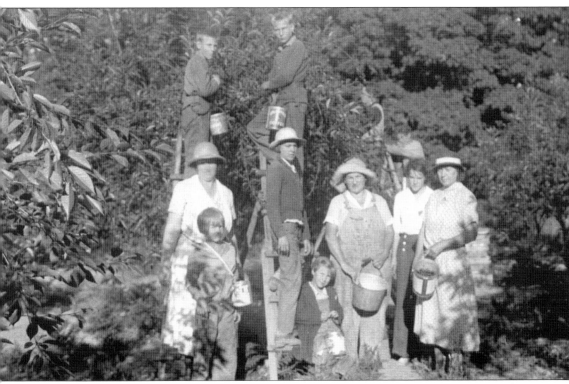

The Brehms family of Deer Harbor poses in their orchard in this 1914 photograph. As was the case with other island farms and families, picking time at the Brehms's orchard brought all hands out to work. Even the youngest could do some chore to help out, and all were expected to contribute to the family effort.

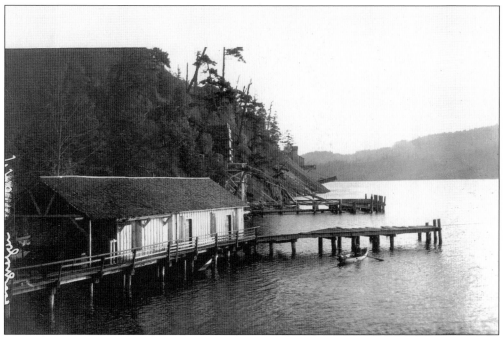

Pride of place belongs to the Langdon Lime Kiln as the first commercial business of size on Orcas Island. This dock was the first constructed on East Sound, and early visitors and homesteaders traveling to the little population center at the head of the bay had to disembark there and walk several miles on a rough forest trail to their destination.

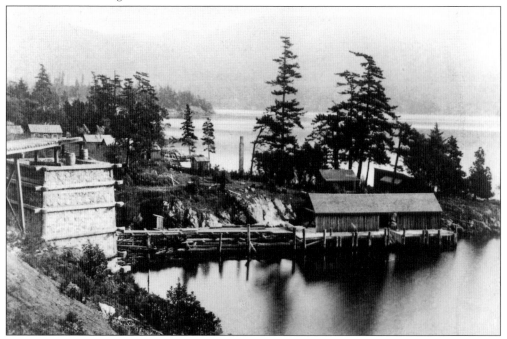

This 1888 photograph of a limekiln near Eastsound gives an idea of the amount of work that was necessary to construct the kiln, dock, and associated building required to produce lime from rock.

This woman is standing in the Hadalgo Lime Quarry near Dolphin Bay in this photograph taken during the heyday of the limekilns. Lime was extracted from the limestone rock by heating the rock to 1,600 degrees Fahrenheit. This produced the white powder lime that made up an important ingredient in concrete, along with many other uses. Lime kilns were tree destroyers, burning on average four cords of wood each day while the kilns ran around the clock, seven days a week. It has been estimated that the limekilns on Orcas Island consumed more than 2 million cords of wood over approximately 50 years. Lime was a dangerous product to transport, particularly since all shipments from the island were necessarily made by ship. If the lime got wet it slaked, or underwent a chemical change. This process produced sufficient heat to cause combustion, with ships being lost to fires that could not be extinguished. Orcas Island lime was used extensively in the rebuilding of Seattle after the devastating fire of 1889 and San Francisco after the great earthquake of 1906. Transportation costs, and other factors, contributed to the decline of the lime business on Orcas Island during the Depression. A few old, unused kilns still exist on private lands scattered around the island, but the limekiln era is over.

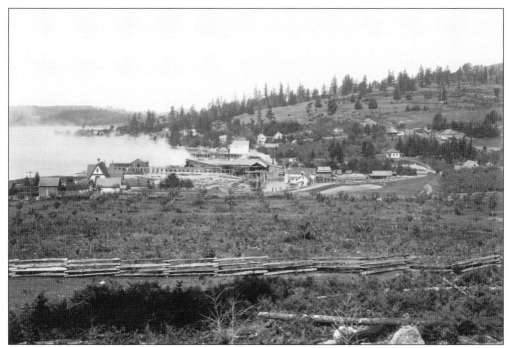

In 1910, Chase Brothers Sawmill at West Sound was a thriving operation. The fields and surrounding hills testify to the logging that has already cleared much of the area for agriculture and homebuilding, while the mill stands at the water's edge, ready to receive the rafts of logs cut elsewhere on the island. Island communities grew up around the sawmills, fish traps, and limekilns that provided employment for the local men and new settlers.

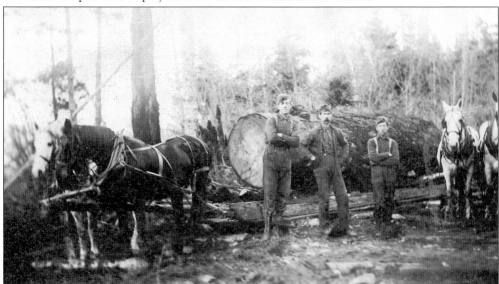

In the early 1900s, teams of horses and oxen were used to skid the logs out of the woods. Here the Wes Langell and W. G. Hambly teams stand with the next section of tree headed for the sawmill. "Grease monkeys" sloshed oil or animal grease, sometimes lard, onto the corduroy of logs laid down to "skid" the logs down to the waterfront, where they were rafted up and towed to the mill.

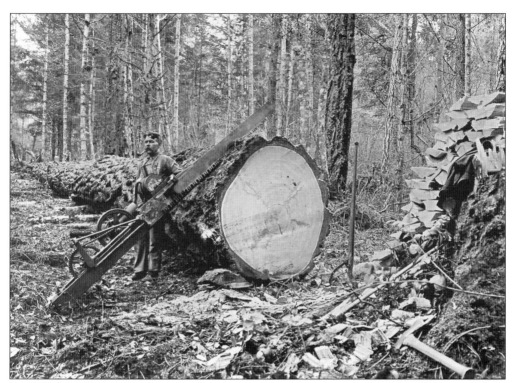

In 1917, John Shambolt takes a break before returning to the simple task of turning this little log into stove wood on the old Olson place in Deer Harbor. His finished work is stacked on the right of the picture while he smokes his pipe and contemplates firing up the motor-driven saw to cut another round from the log. A single tree could provide several cords of wood islanders used for heating and cooking in the homes, usually built of similar logs.

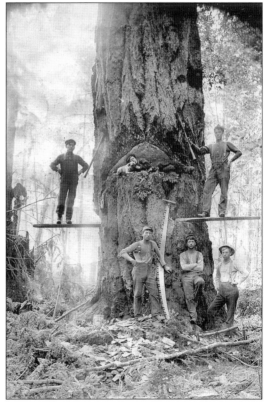

In this 1904 photograph of logging at what is now the YMCA Camp, Don and Dwight Baker stand on the springboards while their brother Bud lies in the cut with their dog. Standing by the saw at the base of this typical Orcas Island fir tree, from left to right, are Bob Light, Jim LaPlant, and Archie Bay. It will definitely occupy their time for a little while. The island forests were full of such giants as this, providing ready material for cabins, sawmills, lime kilns, boatbuilding, and the myriad other uses the settlers found for the straight-grained fir that grew so clear and true.

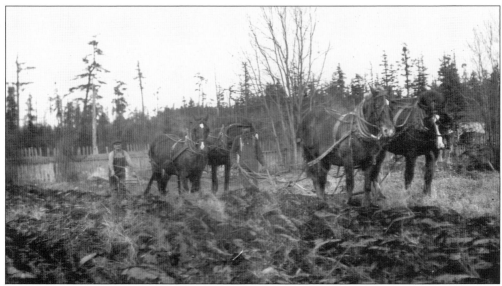

Farming on Orcas Island required a lot of hard work, as evident in this 1914 photograph of George Sutherland and Jake Cramer plowing with their teams of draft horses. The land had to be cleared of the old-growth fir, cedar, spruce, and hemlock trees before the ground could be broken by plow. Alders and other small, fast-growing trees quickly invaded the cleared fields unless a diligent effort was maintained to prevent their growth. Orcas Island farmers soon learned that crops were easily grown in the fertile soil and mild climate, but weeds grew just as well.

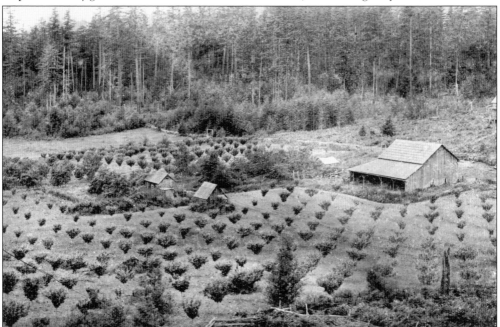

The popularity of fruit farming is demonstrated in this 1900 photograph of the orchard at the Clark farm, near West Sound. E. V. Von Gohren proved through experimentation with thousands of fruit trees that five to seven varieties of apples were the most that should be grown in a single orchard. His work with Italian prunes demonstrated the excellent commercial potential of that crop, and prune orchards were soon planted from one end of Orcas Island to the other.

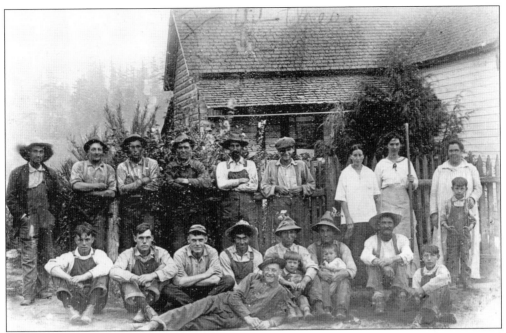

In the summer of 1915, this was the harvest crew at the Emile F. Scheib farm. Value was placed on large families, evident by nine Scheibs who joined the neighbors and hired men to bring in the harvest.

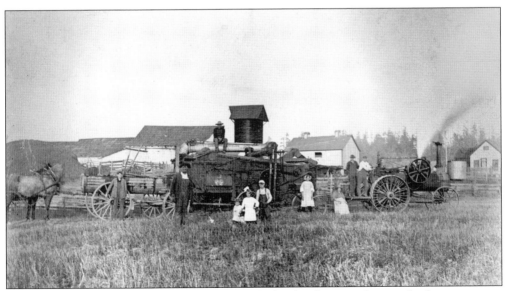

In 1915, members of the Scheib family pose with the threshing machine and other equipment on the Scheib farm.

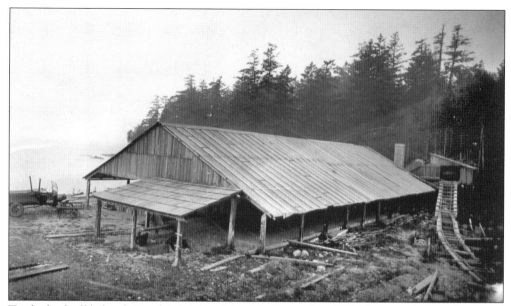

Tracks lead off behind Kimple's brickyard in this September 1925 photograph. The brickyard was built near a favorable vein of clay found close to the beach and enjoyed great success for many years.

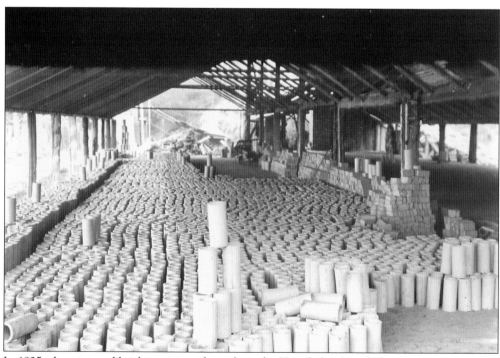

In 1925, clay pipe and brick are in good supply at the Kimple brickyard plant.

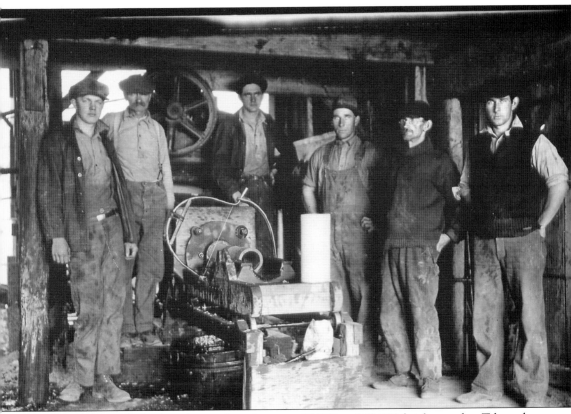

By 1901, the Kimple brickyard turned out between 15,000 and 20,000 bricks per day. Tile and pipe were also popular, particularly among the island farmers who wanted to irrigate their orchards in the drier summer months. Owner Lute Kimple stands second from the right in this September 1925 photograph of his crew at the Kimple Brick and Tile Company.

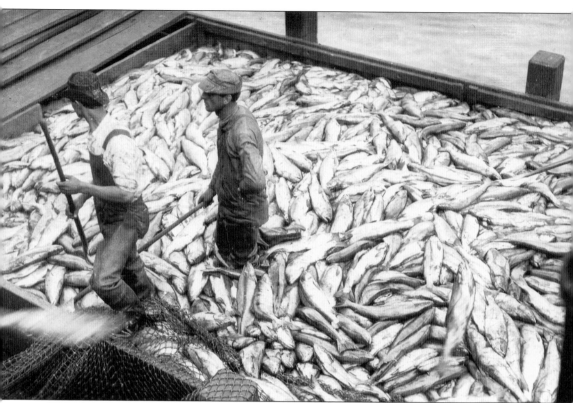

This photograph of men loading salmon in a scow at a fish trap off Orcas Island gives an idea of the sheer volume of fish in the nearby waters. Sockeye, humpback, silver, and Chinook salmon migrated near the Orcas shore at locations and times long known to the local tribes and white men soon learned to build fish traps atop the migration routes. Fish traps were built by driving wooden pilings into the sea bottom at known salmon migration routes, creating an enormous funnel the fish could not escape. Before they were outlawed in 1938, millions of the valuable fish were caught in the traps.

Henry Cayou, who lived at Deer Harbor where his father had been the first white settler, was said to have caught over 5 million fish in his lifetime, many in this and similar fish traps.

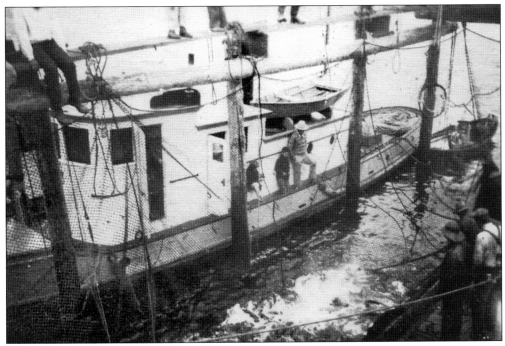

In 1920, the boat operator watches the men on Henry Cayou's fish trap prepare to haul in the catch net.

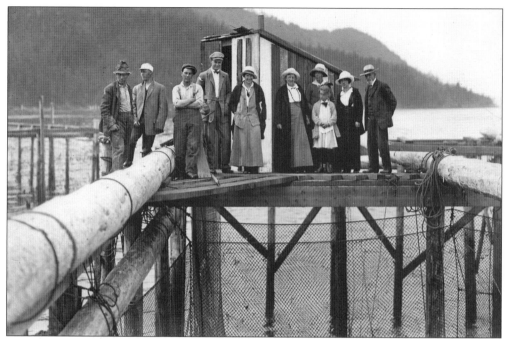

In July 1915, the proprietor, family, and crew pose for the camera on this fish trap at West Beach.

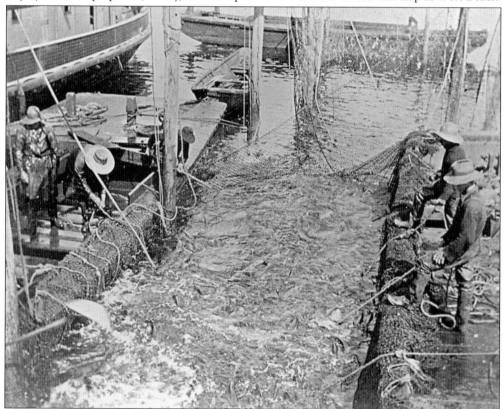

In 1920, the water begins to boil with salmon as the net is hauled in at this fish trap.

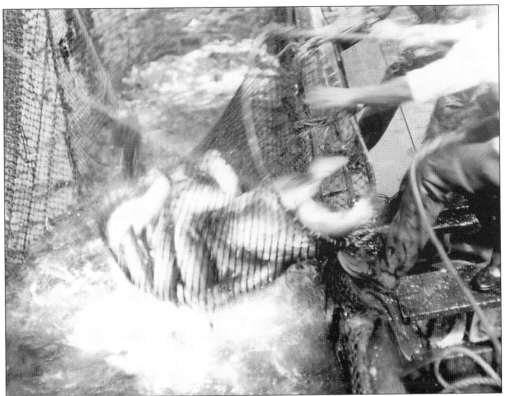

Fish traps were ruthlessly efficient, netting whole schools of migrating salmon as the trap sat atop known migration routes. As this 1920 photograph shows, the hardest work was hauling in a net full of salmon.

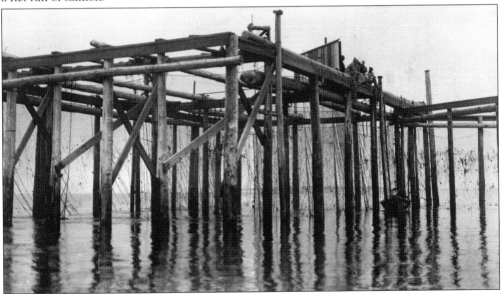

The dense forests on Orcas Island provided a ready supply of the timber needed for construction of the fish traps. In 1915, this fish trap at West Beach gives an idea of the labor involved in building the traps. Once built, however, it took very little effort to catch immense schools of salmon.

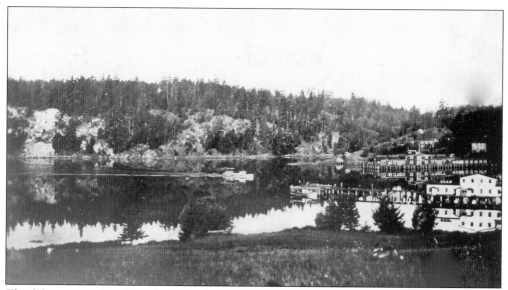

The fish traps produced catches in such volumes that canneries were built at nearby harbors to process the fish for shipment to market. The two canneries in Deer Harbor, one painted red and the other white, are shown in this photograph taken after 1915.

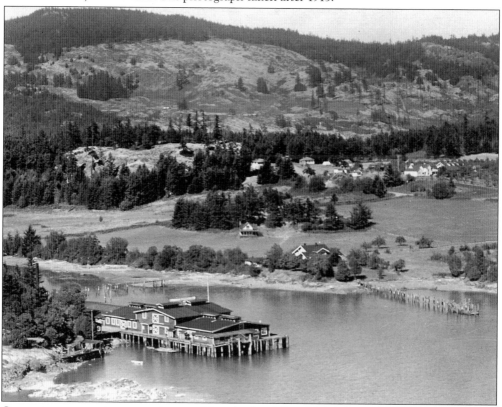

Canneries were major enterprises, and hundreds of Orcas Island residents were employed in the fishing business. The large volume of salmon shipped to the markets helped stimulate the steamship traffic to the island. Pictured here is the "red" cannery in Deer Harbor.

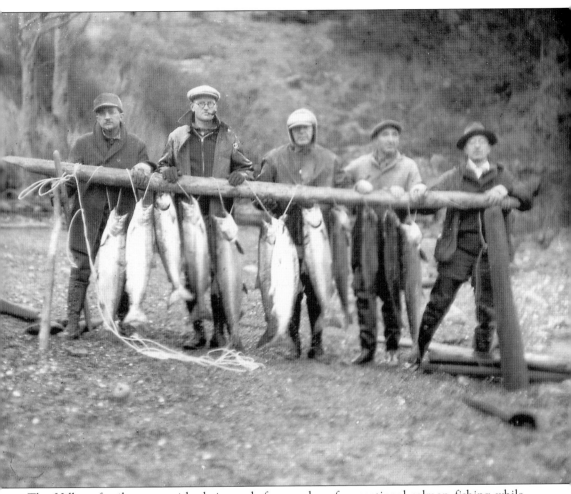

The Hilbert family poses with their catch from a day of recreational salmon fishing while staying at Buckhorn Lodge on Orcas Island. The local newspaper printed weekly reports of the fish caught by the guests of various resorts around the island, with resort owners extolling the virtues of their particular location as the best place for tourists to be sure of catching their limit of salmon.

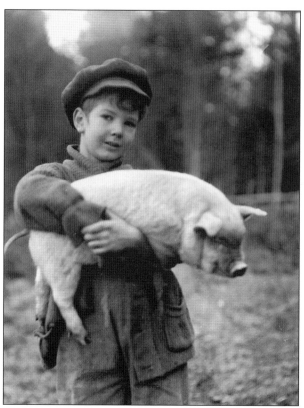

In 1923, Jimmie Geoghegan holds his pig in this photograph taken by his father, James. The plump porker and round-cheeked boy offer ample testimony to the bounty of island farms.

In the summer of 1921, little Richard Geoghegan shells peas. Although most islanders are by nature hardworking people, there is some doubt about Richard's pea production. Island farms provided ample foodstuffs, but all were expected to help with the daily chores and annual harvests.

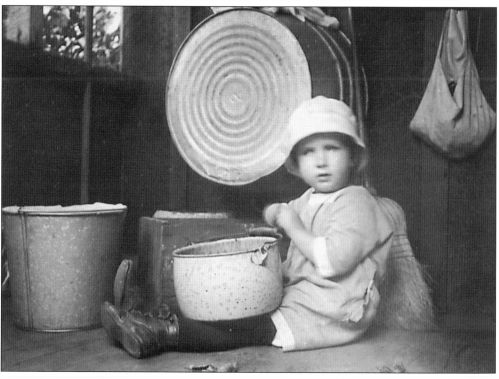

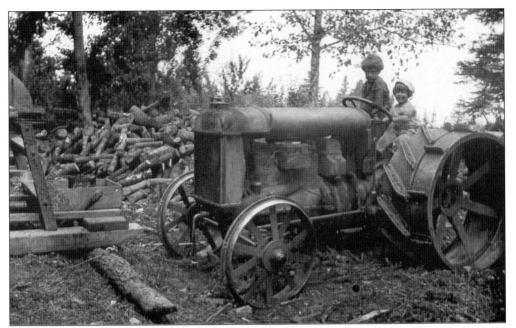

Dickie and Harold Geoghegan pose on the family tractor in this October 1923 photograph. Convenience appealed to islanders as much as anyone and those who could afford to quickly modernized their farm equipment as soon as possible.

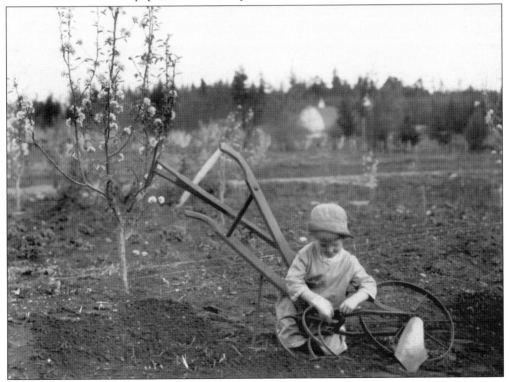

In May 1921, Jimmie Geoghegan is working on the cultivator. The blossoms on the fruit trees mark another planting season on Orcas Island.

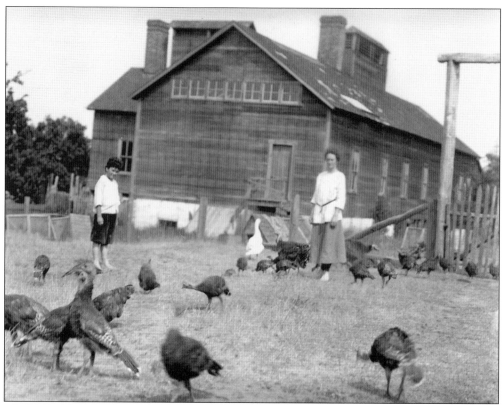

In August 1920, two of the Beck children watch their turkeys eat the rye grass they have thrown to them in the barnyard of their farm.

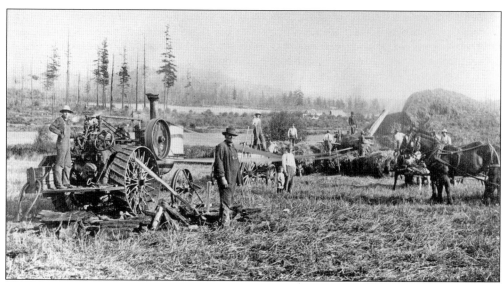

Emile F. Scheib's threshing machine and crew are pictured in 1915 during harvest time.

Four

STEAMSHIP ROUTES
AND WAGON ROADS

The saltwater surrounding Orcas Island defines, enhances, and limits island life, exerting an ever-present influence on island residents since the earliest days of the First Peoples. The earliest forms of transportation over these waters are unknown today, but the dugout canoes made of native red cedar trees are the oldest surviving form, dating back perhaps thousands of years. Sleek, with a distinctive form of sweeping sheer, low freeboard, uplifting bow, and stern ends, and a carved notch almost like a mouth at the very end of the prow, the Coast Salish canoes of red cedar were impervious to insects, seaworthy, and virtually unsinkable.

Natives used canoes for travel, fishing, engaging enemies in battle, carrying passengers or food, and countless other tasks. Early white settlers used canoes until sailing sloops, and then steamboats, became available. As mail service to the various post offices was established, a regular steamboat route to the island began. Most island communities had constructed docks by 1900, including Doe Bay, Olga, Eastsound, Deer Harbor, Orcas Village, West Sound, and Dolphin Bay. The early steamboats were wood-fired and they had to stop frequently to load wood and water for the boilers.

Competition was fierce among the steamboat operators, who were all competing for the same customers on Orcas Island. Freight rates and ticket prices rose and fell unpredictably, falling one day and drastically increasing the next. Steamers serving the island at various times included the *Buckeye, Islander, Lydia Thompson, Rosalie, Mohawk, Anglo-Saxon, Yankee Doodle, Chickawana, Gleaner,* and *Evangel.* Eventually Capt. Harry W. Crosby, a relative of Bing Crosby, organized the first ferry run between Anacortes and Sidney, British Columbia, as an experiment. The *Harvester King,* a 97-foot converted kelp harvester powered by a single, low-horsepower diesel engine, carried a dozen automobiles on her decks on her run through the islands.

The Puget Sound Navigation Company-Black Ball Line on Puget Sound eventually took over the ferry service, operating it for the next 30 years until a dispute ended with the State of Washington assuming control in 1951. All of the ferries serving the island today are part of the state highway department.

When the first white settlers homesteaded on Orcas Island there were no roads, only rough trails and paths between a few points. Early settlers built rough cart tracks, and loggers made skid roads to move timber to the water or mill, but travel on the island was mostly by foot or horse for many years. Wagons came into use as fields were cleared and agriculture became the dominant island pursuit. Roads in and near the settlements were improved.

Early road crews were local men who were paid 25¢ an hour to build roads by hand-clearing and expanding the footpaths and trails, camping out during the week while they worked and returning home on Sunday. Increases in farming generated wagonloads of product that required usable roads for shipment to the docks and those roads were gradually extended and improved as commerce on Orcas Island grew during the last decades of the 19th century.

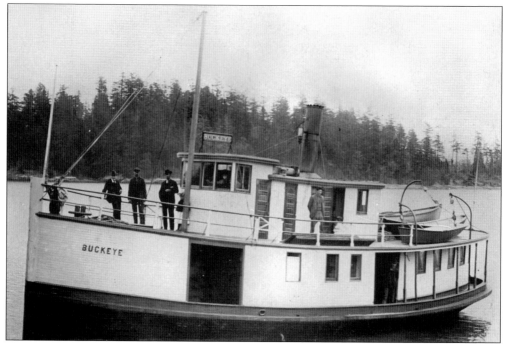

Purchased in 1892 by Capt. Andrew Newhall, the 61-foot, 87-ton steamship *Buckeye* operated on the Whatcom-San Juan Islands mail route. The *Buckeye* had an immediate impact on freight and passenger traffic by providing competition to the previous monopoly, which reduced rates and led to improved service. Long a familiar sight to Orcas Islanders, the *Buckeye* was eventually retired in favor of the *Islander*, a larger boat built by Andrew Newhall at his boatyard on Cascade Bay.

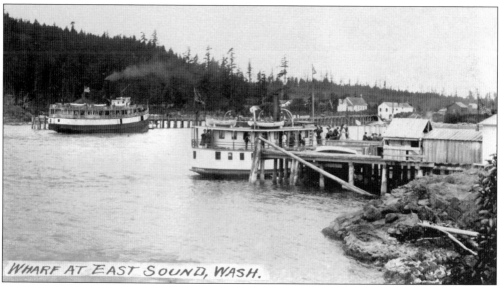

Two steamships are docked at the Eastsound docks in this photograph from the late 19th century. In the background, Templin's dock had to reach out a long distance from shore to ensure boats could dock at low tide. The Madrona dock, in more favorable deep water near shore, was the primary dock for passengers arriving in Eastsound.

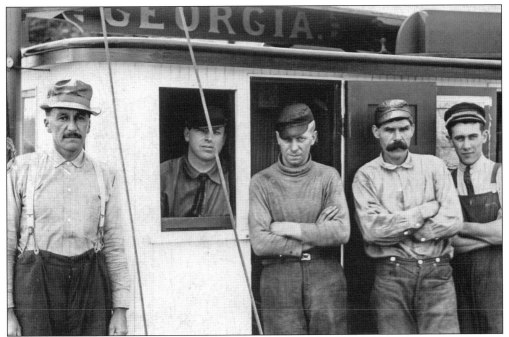

The crew of the steamship *Georgia* poses at the wheelhouse in this photograph. Feeding the steam boiler required constant effort and a steady supply of cordwood cut to a precise length to fit the firebox. Early steamboats pressed crew and passengers alike into service when they had to stop and comb island beaches for driftwood.

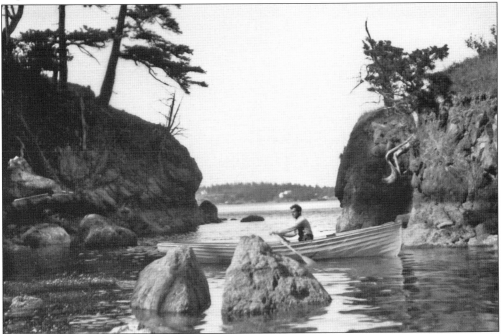

The difficulties of navigating the rocky shoreline of Orcas Island can easily be seen in this photograph of a man rowing his boat. Early settlers found it much easier to visit island neighbors by boat than by walking over the nearly roadless, heavily forested island.

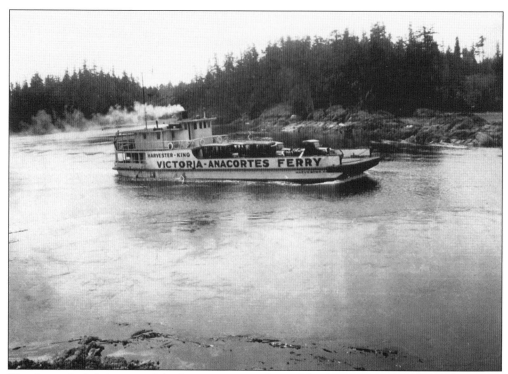

The first scheduled automobile ferry service to Orcas Island came via the *Harvester King*, a converted 92-foot kelp harvester able to carry a dozen automobiles on a five-hour trip between Anacortes and Sidney, British Columbia.

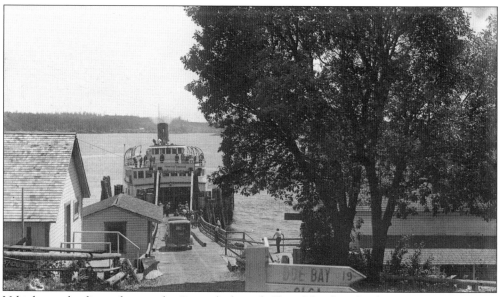

Vehicles are loading a ferry at the Orcas dock, with Shaw Island in the distance.

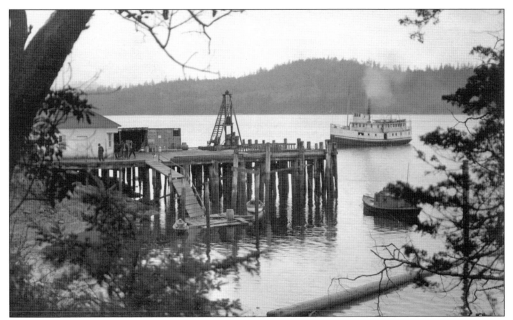

The steamer *Islander* approaches the Eastsound dock. The tripod arrangement on the dock was used to drive pilings. Eastsound was the most popular arrival point for visitors to Orcas Island for many years, eventually replaced by Olga and finally Orcas, as steamship and mail routes changed. All scheduled ferry service now arrives and departs from Orcas; only a few pleasure craft dock in Eastsound today.

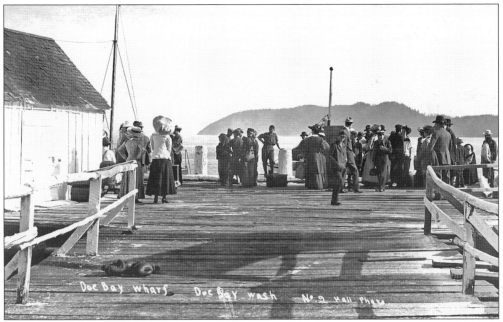

A common sight in steamship days, these people are waiting on the Doe Bay dock for their ship to come in. Many captains considered the schedule merely a rough guide, variable when necessity or whimsy required, and passengers were often left waiting at the dock for hours or days.

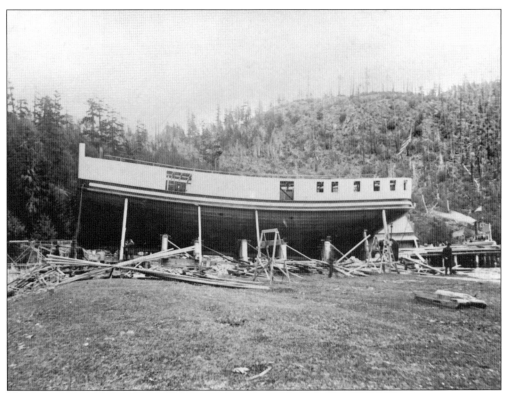

This early photograph shows the *Islander* under construction at Newhall. The *Islander* replaced the *Buckeye* on the Whatcom-Newhall mail route and was a popular boat among Orcas Islanders for many years.

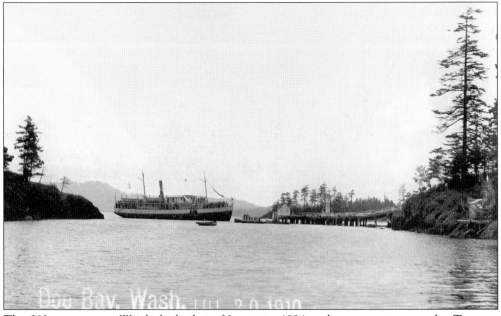

The 293-ton steamer *Waialeale*, built in Hawaii in 1884 and now running on the Tacoma-Vancouver route, dwarfs the Doe Bay dock as it stops for a visit in July 1910.

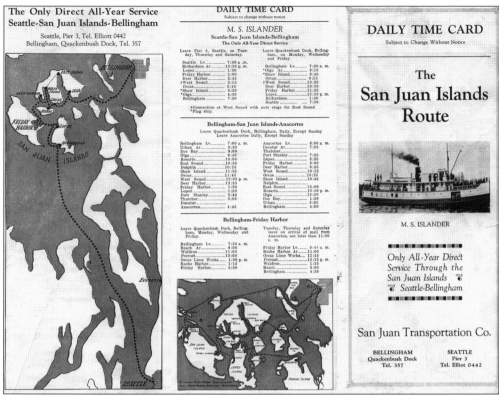

Here is the schedule of the *Islander*, a popular craft that plied the island waters for many years. Schedules were often honored more in the breach than the observance; it was not unusual for people to be stranded for hours or even days at the dock, waiting for the "scheduled" steamship to arrive. Mr. Sutherland is said to have built the Orcas Hotel so the people stranded at the dock would have a place to stay.

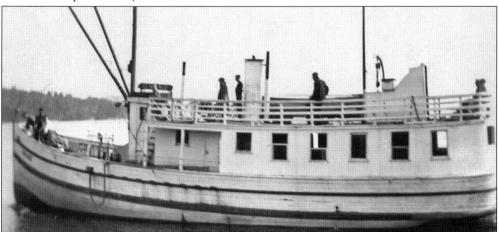

The mail boat *Osage* was always a welcome sight when it came into the dock, carrying passengers, freight, and news from the other island communities and mail from the mainland. Capt. Sam Barlow, skipper of the *Lydia Thompson*, made over 20,000 trips through local waters during his long career. He was said to be able to navigate through heavy fog by smell alone and was a popular figure among the islands for many years.

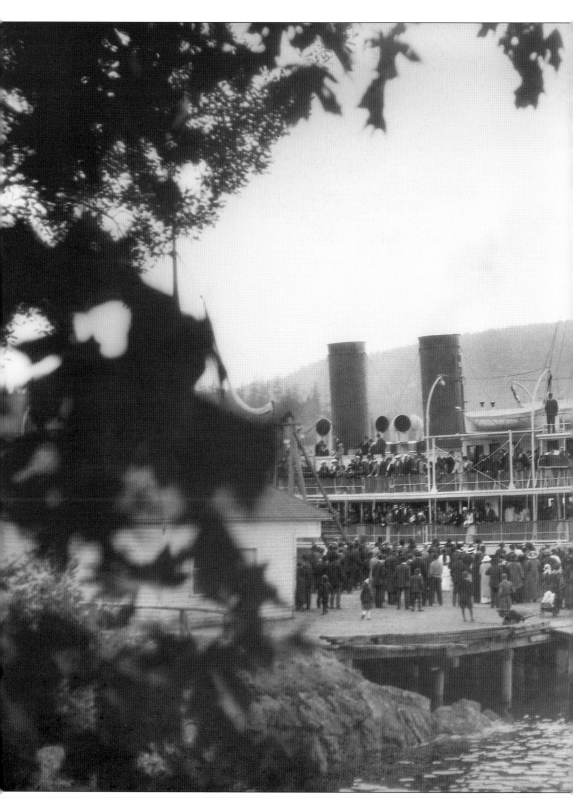

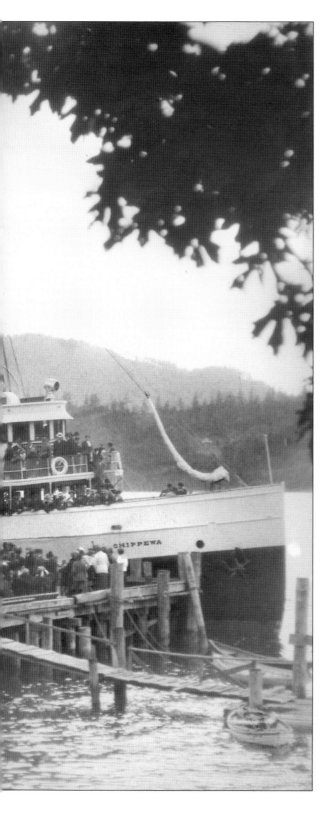

In June 1914, the *Chippewa* is full of passengers at the Madrona Point dock. Orcas Island was a popular destination for Seattle residents, who could travel to the island and stay for a few hours of sightseeing, climbing Mount Constitution, picking berries or beachcombing, and then return home the same night.

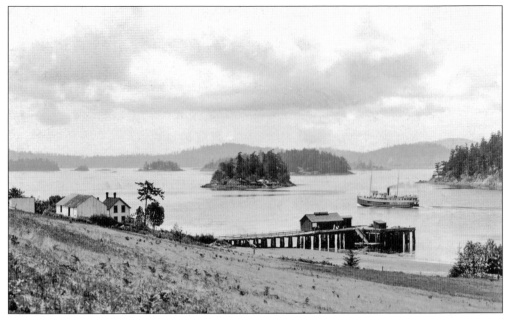

The Deer Harbor store, post office, and dock are in the foreground as the mail boat steams out of the harbor. Fawn Island lies ahead of the boat, with Spring Point on the right and other islands of the San Juan group in the background.

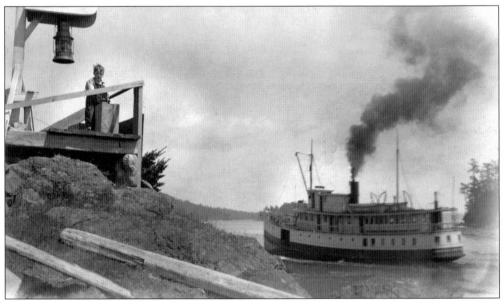

The Pole Pass light hangs to the left of the *Islander*, which is steaming through the pass. William Caldwell, an early settler, made an agreement with the captain of the SS *Libby*, crossing through the pass three times a week on the Port Townsend-Semiahmoo mail route, to hang a light on a pole when the steamer was due. From 1890 to 1907, Robert McLachlan managed the light on a daily basis. His son Kirk took over in 1907 and managed it for many years after.

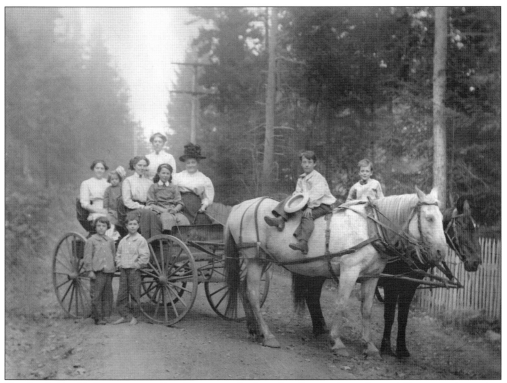

Elizabeth Reddick poses in her buggy with her family at the edge of Eastsound in this early photograph.

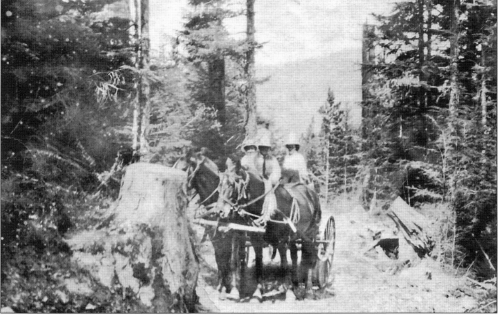

Wes Langell drives a wagonload of tourists up the Mount Constitution road from Olga. Local men stimulated commerce in their settlement by constructing this road up the mountain in 1894, attracting mainland visitors eager to see the famous view.

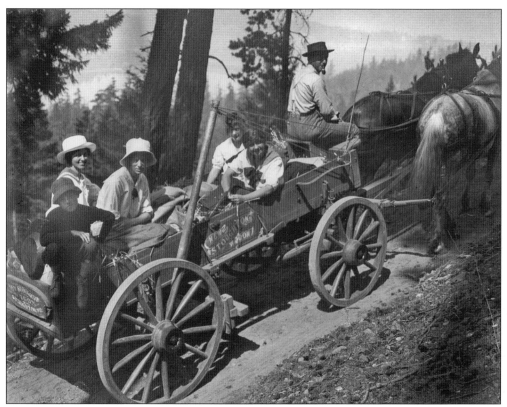

Good wagon brakes were an important part of the equipment when Wes Langell drove tourists to the top of Mount Constitution in the early 1900s. The road was steep, had many switchbacks, and could only be safely traveled in good weather.

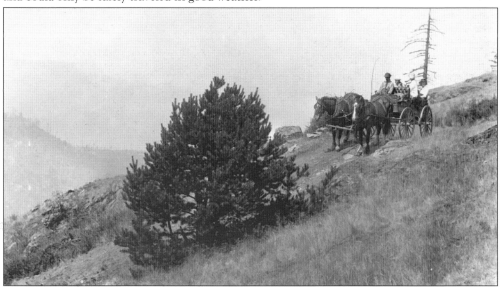

It took several hours to make the wagon trip up the mountain and back, requiring steady nerves and calm horses to safely transport the tourists and vacationers who came to see what is widely believed to be the finest marine view in North America.

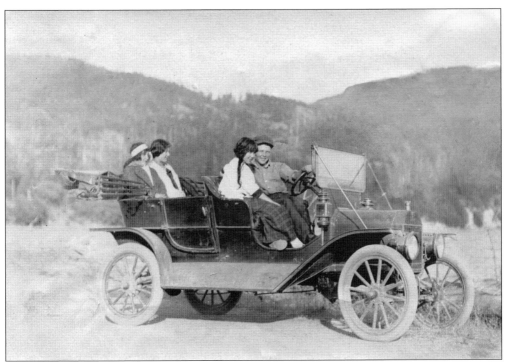

Karl "Charlie" Rilling poses with friends in his 1910 Model T, the first automobile to climb all the way to the top of Mount Constitution in 1912.

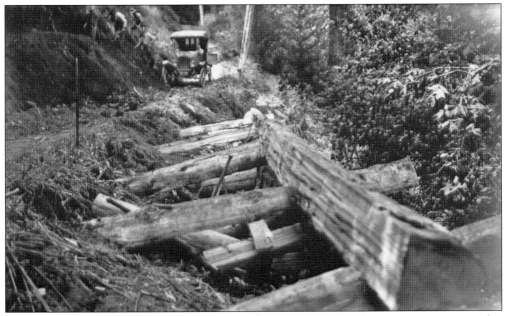

Widening the Olga Road for automobile traffic was no easy task, as one can see in this photograph of the road under construction.

Island roads were smooth and well traveled near the small villages, but could be rough and almost impassable at outlying points. In the early 1890s, there was still no road connecting Olga and Eastsound and local citizens petitioned the county for funds to build a road around Cascade Lake to enable wagon travel between the two settlements. County commissioners approved an expenditure for $40 of dynamite and local men blasted a rough, one-way wagon road out of the rocky bluffs alongside the lake.

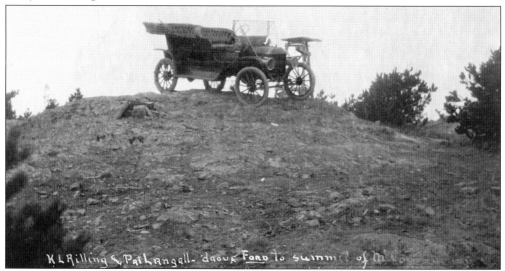

Charlie Rilling and Pat Langell drove this 1910 Model T Ford to the top of Mount Constitution in 1912, the first automobile to reach the summit. Langell ran alongside and squirted gasoline into the carburetor on the steepest parts, rode the running boards when he could, and both men cut brush and trees along the way in their three-hour struggle to reach the top of the mountain. Locals were astonished by the feat, which it was said had reduced the car to a quivering mass of nuts and bolts by the time it reached the bottom of the mountain.

Five

RESORTS

The unique geography of Orcas Island includes over 125 miles of coastline surrounding the island interior, offering a wonderful diversity of sandy beaches, rocky coves, and harbors, and a myriad of water vistas. Mount Constitution, at 2,409 feet, the highest mountain in the county, offers what is reputed to be the best marine view in North America. Visitors to the island found an ideal vacation spot close to mainland cities and towns, and many found on repeat visits that Orcas Island offered a wide array of pursuits for those with time to enjoy them.

The earliest resort on Orcas Island was Norton's Inn in Deer Harbor, where vacationers could rent platform tents (canvas tents constructed on wooden platforms). This so-called "tent camping" was preferred, as guests in those days favored the simple life most akin to camping out. As word spread of the beauty of the land and the gentle climate on Orcas Island, other resorts opened at different locations around the island.

The development of new resorts stimulated the trade and attracted a wealthier clientele. After 1925, resort owners noticed their guests desired cabins more than tents, and all manner of cabins and cottages were constructed to appeal to the more genteel class of vacationers. Families could stay in housekeeping cottages with kitchens and separate rooms, or in sleeping cabins with meals provided in a central dining facility, or a lodge dining room.

The fledgling resort industry initially capitalized on the abundance of salmon in the surrounding waters, but over time sightseeing, beachcombing, hiking, riding up Mount Constitution, and other pursuits joined fishing as major attractions. Vacationers found the islanders warm and friendly in manner and eager to make their guests comfortable, entertaining in a "family" style unique to the island. A complete absence of saloons, taverns, and other adult venues made Orcas Island a favorite destination for those seeking a wholesome atmosphere in which to enjoy nature's bounty. Many returned year after year to the same favorite resort.

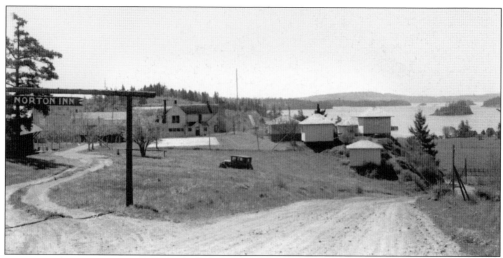

The first Orcas Island resort, the Norton Inn, was built by Patrick and Mary Norton, who moved to the Deer Harbor area in 1891. The resort consisted of timber-framed, canvas-topped structures built originally to house the Seattle schoolteachers who had made a yearly tradition of vacationing at the Norton's place. These structures became the nucleus of the resort, which grew to include a 150-seat dining room, tennis courts, and a saltwater swimming pool. Mary Norton was famous for her chicken dinners, and a good crowd of islanders could be counted on to mingle with the guests in the dining room. The Norton's son Felix and his wife, Esther, took over the resort in 1931 and operated it for many years. Still in business today, the resort is now known as the Deer Harbor Inn.

Guests stand before the West Sound House, built by W. H. Dexter in 1897 at West Sound. It was one of three island resorts operating at their peak before the 1930s. West Sound House provided lodging for visitors on business as well as vacationers. Flush with the latest amenities, West Sound House also boasted a two-story outhouse (seen here), with the traditional crescent moon, at the rear of the building.

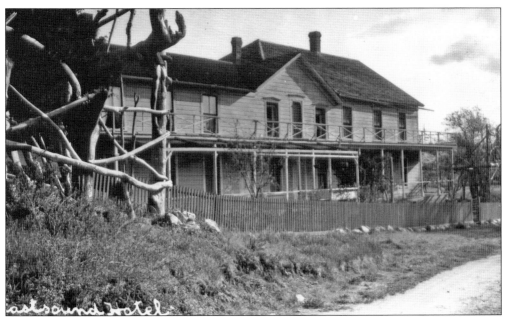

The oldest island inn, the Outlook Inn, dates to 1891 when it was named "East Sound House" by the owner, Luther Sutherland. Purchased from Charles Shattuck, the first white settler in Eastsound, it has been variously named Mount Constitution Inn, Beach Lodge, and finally, Outlook Inn. Fred P. Meyer of Seattle bought the property in 1941, when it was renamed the Outlook Inn.

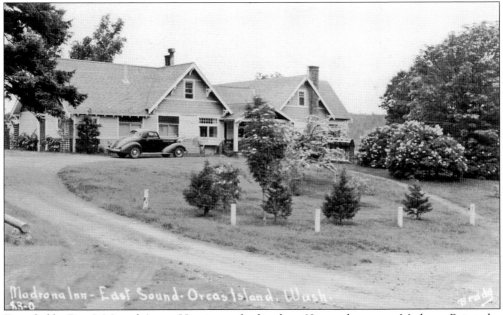

Founded by Drs. I. M. and Agnes Harrison, who lived on 60 acres known as Madrona Point, the Madrona Inn eventually grew from 3 to 24 cabins, with a central lodge, dining facility, and large dock. Started in 1913, the Madrona Inn was for many years the premier island resort, attracting vacationers from throughout the United States. Some "repeaters" came annually for more than 20 years.

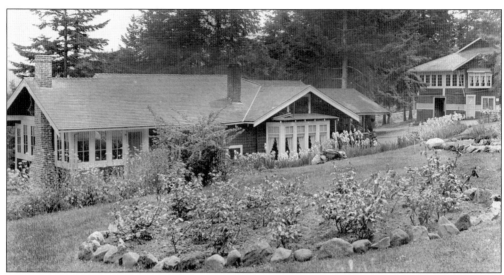

Waldheim, which means "forest home" in German, opened in 1916 on the hill overlooking East Sound Bay and Eastsound village. Started by Frank and Mia Opperman, Waldheim eventually grew to 22 buildings, including a dining room that seated 75. The teachers at the Eastsound schools boarded here for many years, and Mrs. Opperman's chicken dinners were popular with island residents. All the guest cottages had fireplaces and for many years, Mr. Opperman cut and delivered kindling wood to each cottage every morning. Guests could play croquet, tennis, or ping-pong at the resort. The village of Eastsound was close for shopping or beach excursions.

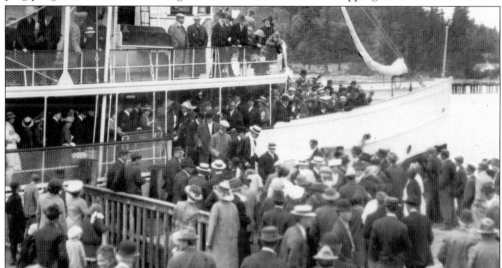

Weekend or holiday excursionists disembark at the Madrona dock—the primary passenger and freight dock in Eastsound. The beauty of Orcas Island became more widely known and appreciated as Seattleites and others became acquainted with her on excursion trips through the islands. Templin's Fair dock and the East Sound House (now the Outlook Inn) are in the background as the passengers flock ashore from the steamship SS *Chippewa*. The sleepy village of Eastsound quickly transformed into a bustling metropolis when steamships full of nattily attired city folks pulled into the dock—and quickly sank back into a sleepy, rural village when they departed. Visitors could take wagon rides up Mount Constitution, swim at Crescent Beach, fish and hunt in season, and "get away from it all" in a vacation paradise close to home.

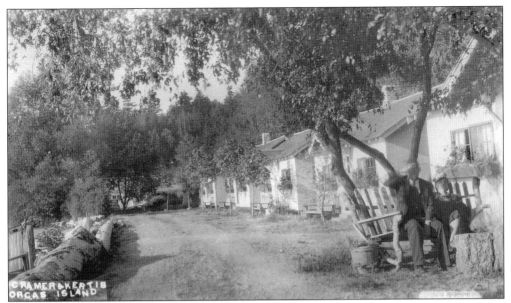

In 1938, near Eastsound, a fishing resort known as Cramer and Kertis was built by Mr. and Mrs. Earl J. Cramer. They also operated the resort. It had 10 cabins that could be rented furnished or unfurnished, and shower and laundry facilities in the boathouse.

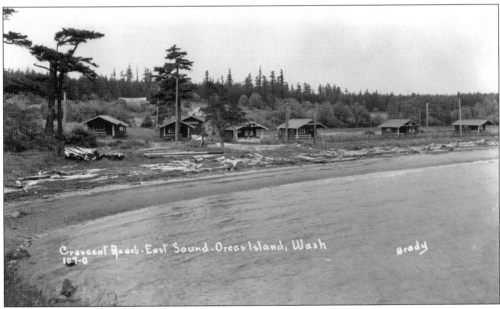

In 1915, Crescent Beach Cottages, owned by Ida Huteson, was built at Crescent Beach just east of Eastsound and Madrona Point. The resort consisted of eight housekeeping and one double cottage right on the beach, long considered the finest sandy beach on Orcas Island. Mr. and Mrs. A. S. Cave bought the resort in 1937 and operated it until the late 1940s.

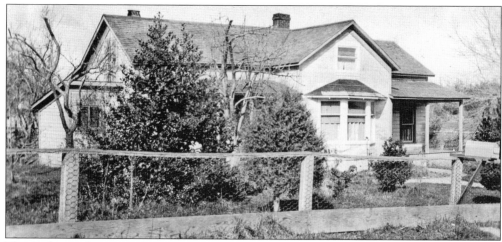

The *Friday Harbor Journal* on July 18, 1908, stated, "With scenic beauty on every hand, with climatic conditions that are well nigh perfect and with a medicinal spring within walking distance, East Sound is obviously an ideal place for a sanitarium and there can be no doubt that advantage will be taken of the establishment which was opened last fall." The journal was referring to Bonnie Brae, opened in 1907 by Payton and Elizabeth Reddick as a health spa and birthing center. Elizabeth served as the in-house midwife and assisted Dr. C. O. Reed in the delivery of many island children. Dr. Reed was in charge of the patients, some of whom stayed at the facility for up to two weeks after giving birth. In later years, Bonnie Brae served as a boarding house for tourists and teachers. The central portion of the building was constructed by Charles Shattuck, an early homesteader, in the late 1800s. The Reddicks named the farmhouse Bonnie Brae in honor of their Scottish roots.

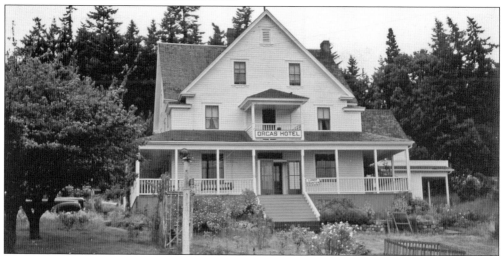

Overlooking the ferry landing at Orcas, the Orcas Hotel is a familiar sight to all ferry riders. Built in the years 1900–1904 by Joseph Van Bogaert for W. E. Sutherland, the hotel was originally intended to house stranded visitors in the days when travelers had to rely on erratic steamship schedules. The hotel was built in the balloon style of architecture—vertical boards were 40-feet long, the walls were raised complete without stops, and the floors were hung from the walls. Tent cabins, to expand capacity for more guests, were constructed to the west of the hotel in 1916 and a dining room was added the same year. In early days when guests departed at the end of their holiday, the entire hotel staff would send them off with a singing farewell at the dock.

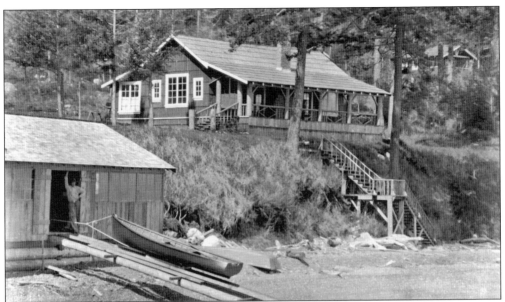

In 1934, Anscel Eckmann and his wife started Buckhorn Lodge on 300 acres near the beach at the base of the north side of Buck Mountain. Sixteen cottages and sleeping rooms in the lodge could accommodate up to 100 guests, who could play badminton, ping-pong, horseshoes, and croquet; ride horses; or rent boats for fishing. An early souvenir book called it a "fisherman's paradise."

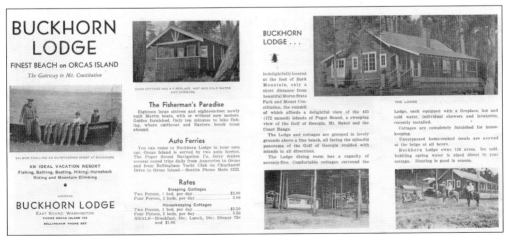

Salmon fishing was an attractive lure for vacationers seeking the "ideal island resort," as Buckhorn Lodge claimed in its advertising brochure. Bathing on the finest beach on Orcas Island, hiking, horseback riding, and mountain climbing were all popular pursuits at Buckhorn Lodge, the "gateway to Mount Constitution."

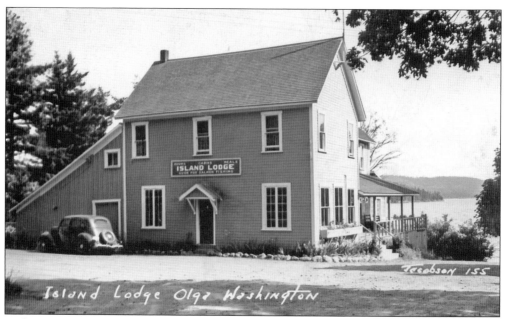

Island Lodge Olga Washington

Built in the early 1890s by John Ohlert, this structure housed a store and post office on the ground floor and a dance hall on the second floor. C. S. Rice bought the building in the early 1900s, and converted it to the Rice Boardinghouse with the addition of nine sleeping rooms. Later known as the Olga Park Hotel, and then the Olga Inn, it eventually became the Island Lodge.

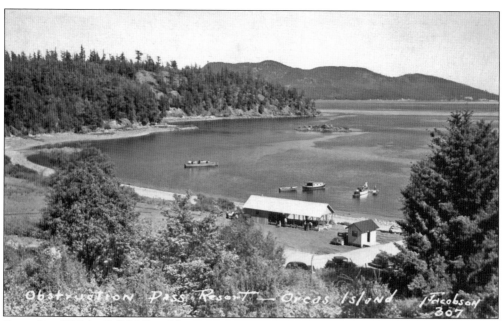

Obstruction Pass Resort — Orcas Island

Started in 1930 by Bill Miller, Obstruction Pass Resort had a store, six cabins for guests, and boats for salmon fishermen to rent. The resort was sold in 1945 to Roy S. Evans, who planned to add a restaurant when rationing restrictions instituted during World War II were removed. The resort was later sold to the Welcome family, who in turn sold it to the Sawyer family.

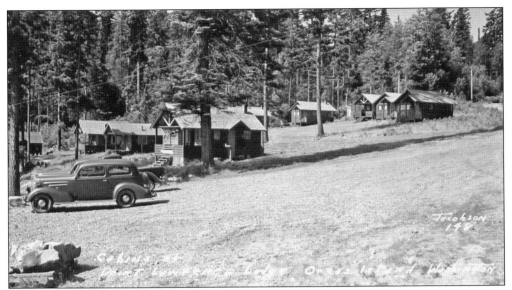

Caroll Culver moved to Point Lawrence at the suggestion of his father, O. H. Culver, during the Depression. He built a cabin so his parents would have a place to stay when they came to visit, but a fisherman rented it as soon as he finished construction. He built another, which was also rented immediately. After the same thing happened again with the next cabin he built, he got the idea that a resort might be successful at the site. In 1935, Point Lawrence Lodge opened to provide lodging for campers who formerly boated to Orcas and camped on the beaches. Ten cabins were eventually built at what a 1949 newspaper ad hailed as the "First Fishing Resort" on Orcas Island.

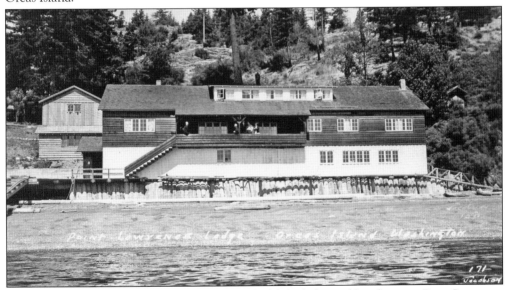

Mr. and Mrs. E. J. Hilbert helped Caroll Culver build the lodge and boathouse at Point Lawrence Lodge and ran the dining room and boathouse for many years. Hilbert sent some of the big salmon caught by fishermen at the lodge to Seattle sporting goods stores and these examples served as fine lures to those seeking trophy catches. Eddie Bauer was among the famous sportsmen who came to Point Lawrence Lodge, as it became widely known for being the "hot spot" for salmon fishing.

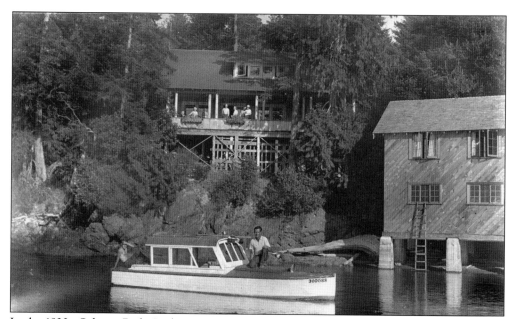

In the 1930s, Salmon Bight Lodge was opened on Cormorant Bay near Deer Harbor by Mr. and Mrs. Fred McCreay. It had four rooms, a boathouse, and a dining room. In 1940, it was renamed "Casa Mar Silva" (House of Sea and Forest) to indicate it was more than just a fishing resort. After the resort closed, the site became the location of a Girl Scout camp.

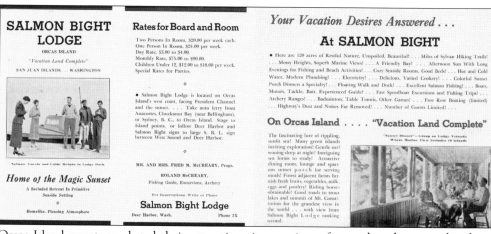

Orcas Island resorts marketed their attractions in a variety of ways, but the resort brochure quickly rose to prominence. Extolling the virtues of the clean island air, open beaches, marine and mountain vistas, and fabulous salmon fishing, resorts competed with one another for the tourist business. Salmon Bight Lodge offered comfortable rooms, good food, and excellent fishing in the "Vacation Land Complete"—Orcas Island.

Six

Schools and Social Life

Education has always been dear to the hearts of Orcas Islanders and never more so than in 1873 when the first island school district was formed in Eastsound. Earlier schools had been part of the Whatcom County School District, but the formation of San Juan County by the territorial legislature in 1873 allowed for the creation of county districts. The first school, in a log cabin along the shore of East Sound, was attended by 28 "scholars" between the ages of 4 and 21, all taught by a single teacher.

The school offered classes to all children on the island, despite the common awareness that most lived too far away to attend school every day. In some cases, travel was too dangerous for the small children, and in others, the children were too busy helping their families to attend school. As settlement on Orcas Island grew, the corresponding increase in school-age children in the little population clusters scattered along the shores and harbors of the densely forested island, nearly totally lacking in roads, stirred local movements for schools.

The earliest island schools were subscription schools held in private homes, but these faded away after districts were organized and enough money was raised to pay teachers and build public schools. Since local taxes and levies provided the funds needed to operate the schools and pay the teachers, downturns in the local economy dramatically affected the schools. Schools might operate for several years, then close for a year or two while the local school board struggled to raise enough money to pay a teacher for another term.

School districts were formed in Olga, Orcas, Crow Valley, Newhall, Deer Harbor, West Sound, and Eastsound. The Deer Harbor School District served students from Crane, Double, and McConnell Islands as well as the local residents. Consolidation of the districts began with improved roads, school bus transportation, and accreditation of the high school, among other factors, finally culminating in a unified school district in 1937, some 64 years after formation of the first school district on Orcas Island.

School activities remain a big part of island life. Athletic games play to surprisingly large crowds, while school plays, parades, and functions never fail to attract islanders interested in what has always been the most precious island resource—children.

Warm, friendly relations between neighbors in the remote island settlements have dominated since early pioneer days. Women's clubs and societies, including the Ladies Aid Society, Madrona Club, Stitch and Gossip, Rebekahs, and others provided opportunities for social gatherings and public service. The Odd Fellows, Maccabees, The Moose, Woodmen, and other fraternal organizations vied with community bands, baseball teams, and political associations for the attention of the men. Even today, the local Grange chapter continues a long tradition of support for farmers on Orcas Island.

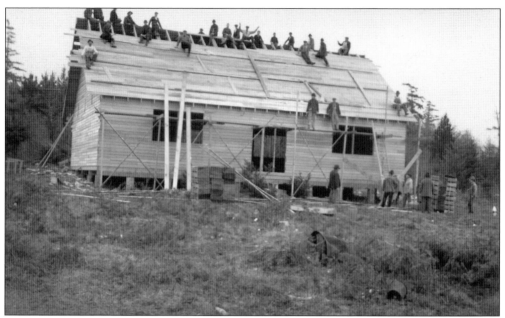

When the community decided the school needed a gymnasium, everyone turned out to lend a hand. This photograph of the roof near completion was taken in August 1918 and nicely illustrates the cooperative spirit of Orcas Islanders.

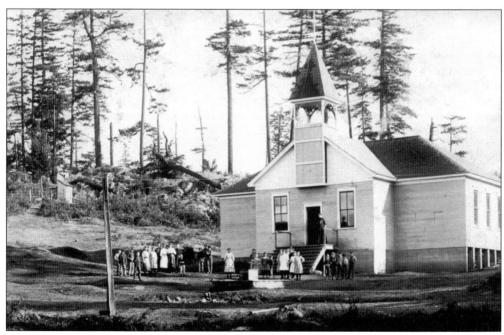

The Deer Harbor School, formed as District No. 16 in 1891, also served children from Double, Crane, and McConnell Islands. Constructed in 1905, this building replaced the original schoolhouse built in 1891. This new structure, a two-room schoolhouse, was greatly needed by the 75 children enrolled at the time. The building is still in service today as the Deer Harbor Community Clubhouse.

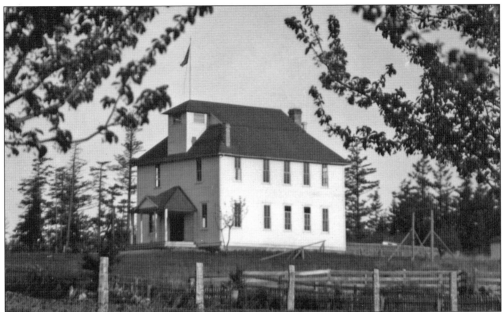

The first schoolhouse in Eastsound was a log cabin near the shore, the second a converted house. The building in this May 1914, photograph, taken from Mr. Pike's orchard, was the third Eastsound schoolhouse. The grade school occupied the first floor, with the high school on the second floor. As the economic life of the island fluctuated, the effect on school enrollment was dramatic; older children attended school or not, depending on family needs. Some years, the upper grades were virtually empty, and the second floor of the schoolhouse became an indoor playroom for the younger children. As the economy improved, enrollment increased once again and the higher grades were re-populated with students eager to catch up on missed grades. For many years, the school at Eastsound only went to the 11th grade; those seeking a diploma had to go to school in Bellingham, on the mainland, where they underwent rigorous testing before graduation. A few students pursued this line of education, but many saw their school days end in the 11th grade, if not sooner. Orcas Island finally had its first high school graduation in 1922, some 49 years after the first school district formed in Eastsound.

The second Eastsound schoolhouse, later a boardinghouse known as Our House, is pictured here in 1905.

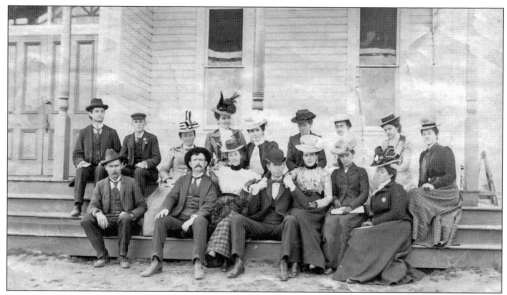

In this 1898 photograph of schoolteachers in San Juan County, Ethan Allen, the San Juan County school superintendent, sits to the left on the first row.

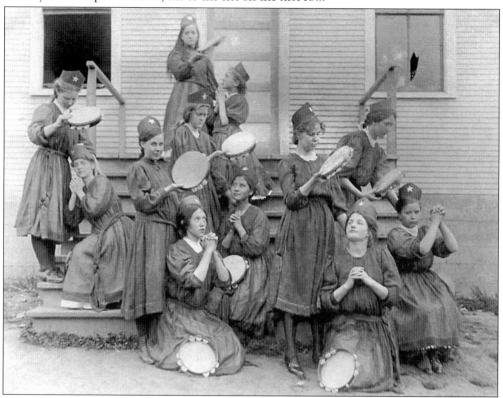

Drama and music come together in this photograph of the Deer Harbor School Tambourine Band as evidenced by the rather dramatic poses of the various members. School pageants, plays, and events were popular local forms of entertainment, well attended by most of the community in earlier times.

In 1914, girls wearing bonnets hold their favorite dolls and teddy bears on the schoolhouse steps.

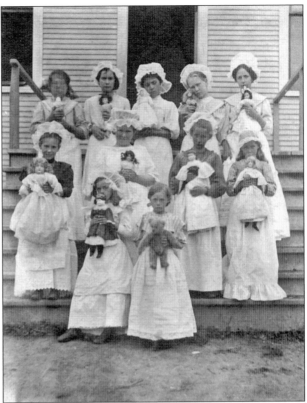

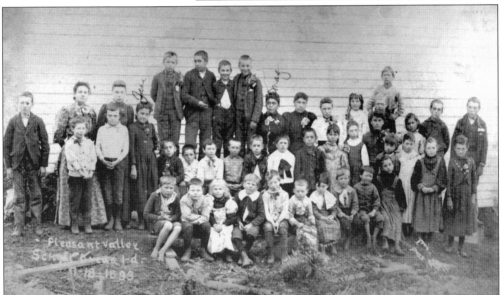

The growing population in the hills and valley between Eastsound and West Sound is reflected in this 1893 image of the schoolchildren and teachers at the Pleasant Valley School. The wide range of ages and classes in a single classroom meant extra work for the teachers, who were charged with keeping strict discipline despite often rowdy youngsters accustomed to independent ways.

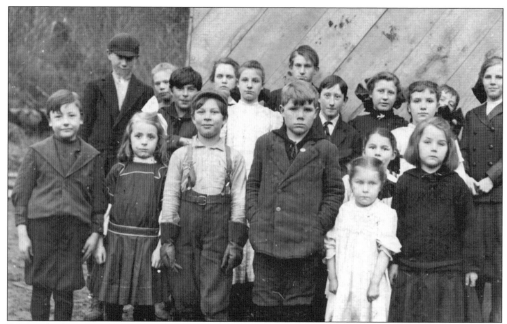

Some students appear happier than others as the Doe Bay schoolchildren pose in this 1912 photograph.

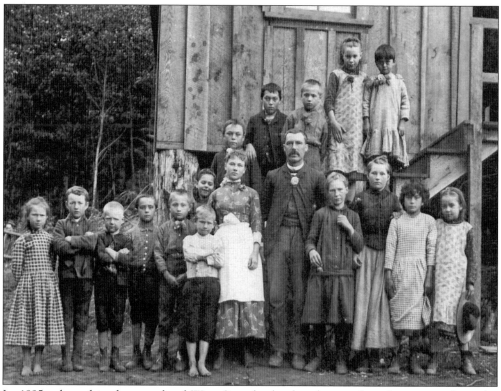

In 1895, when this photograph of West Sound schoolteachers and students was taken, the community at West Sound was growing fast.

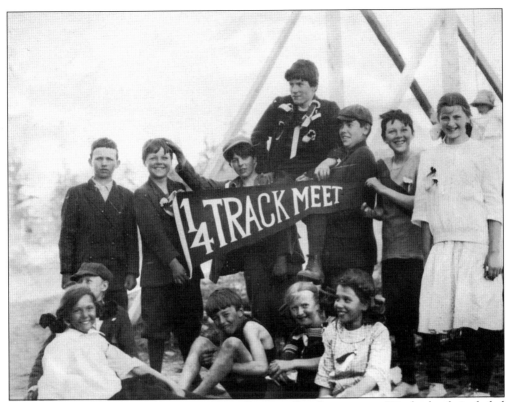

In 1914, the Eastsound track team poses on Crescent Beach at a meet. Rival schools included those on San Juan and Lopez Islands, as well as those on the mainland.

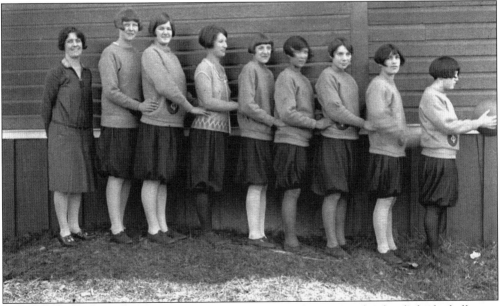

Newly crowned as county champions in February 1927, the Orcas Island girl's basketball team poses with their coach in this photograph. Island children were competitive and resourceful, and athletics afforded a welcome outlet for youthful energies accustomed to hard work at home.

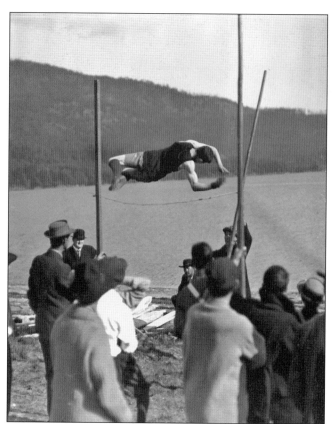

Two stalwart men hold the uprights in this photograph of a pole-vaulter clearing the bar during the school track meet held on Crescent Beach in May 1915.

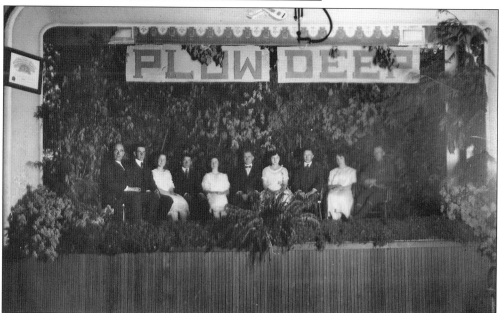

In 1922, Orcas Island High School held its first graduation exercises. The influence and importance of agriculture on Orcas Island residents is easily seen in the bannered admonishment for the graduates to "Plow Deep" as the small, well-dressed class sits on the stage.

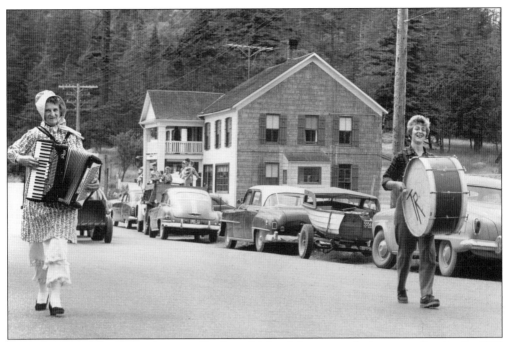

Pat Kale keeps time on the drum as Charlotte Hiskey Johnson works her accordion in the 1955 Historical Days Parade. Boats, cars, and a truck full of island youngsters line the street in front of the Outlook Inn on Eastsound's main street as the parade meanders past.

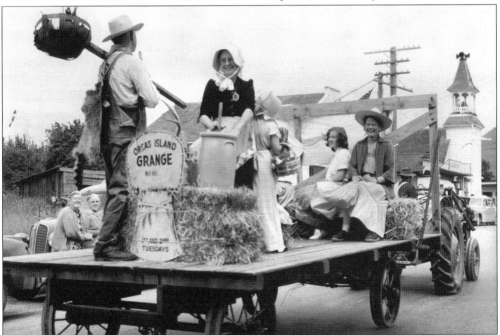

The Grange remains an active part of community life on Orcas Island, as it was in 1955 when this float celebrated the local chapter in the Historical Days Parade. The island economy depended for many years on agricultural products, and the Grange provided valuable services to the farmers and orchardists of Orcas Island.

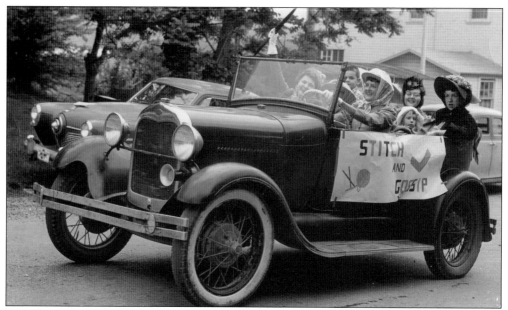

Proudly announcing their favorite pastimes, the Stitch and Gossip Club of Orcas Island participates in the 1955 Historical Days Parade. The Green Hornet, an old touring car, is piloted by Peg Bills, who is joined by Mamie Conrad, Mrs. Herbert Bills, Dorothy Brown, Betty Warner, Clara Soule, Mary Schoen, Steve Schoen, and an unidentified youngster on his mother's lap. There was no doubt the Stitch and Gossipers knew how to have a good time, as can be seen by the gloved hand raising the umbrella in a jaunty salute to the camera. Dressed in vintage clothing, the Stitch and Gossip Club had one of the most photographed entries in the parade.

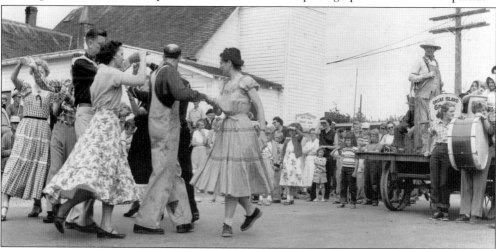

The Orkie Square Dancers do-si-do through the intersection as the crowd looks on during the 1954 Historical Days Parade. Mr. and Mrs. Glen Walberg, Mr. and Mrs. Earl J. Cramer, Inez Stearns, Howard Porter, and Mr. and Mrs. Lee Ammerman make up the set of dancers giving the exhibition. Grange members on their float join the tourists and other islanders in appreciation of the dancers, who are all dressed in their best island square dancing attire. Dancing has an honored tradition in island history; early dances were often the only occasions when neighbors could meet and visit, kids could play with others their age, and young folks might "spark." Square dancing remained a popular dance style on Orcas Island for many years.

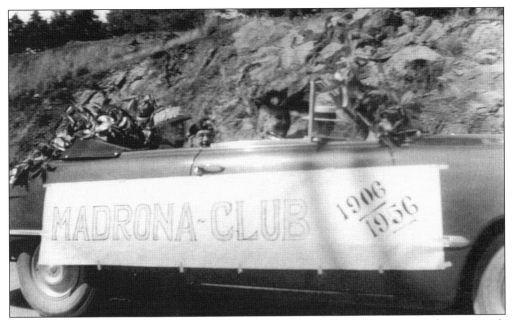

The Madrona Club, an island philanthropic organization, celebrated 50 years of service with this entry in the Historical Days Parade. The Madrona Club was instrumental in organizing the first medical center on Orcas Island, the first lending library, and the first official Washington State Park on land donated by Robert Moran.

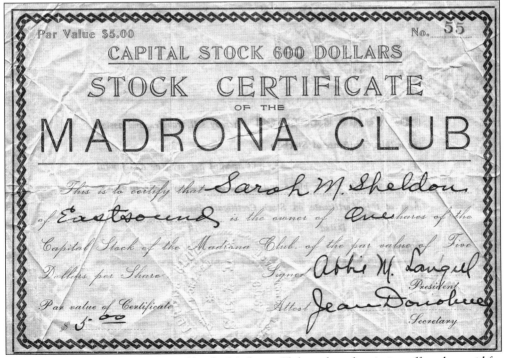

These stock certificates were issued by the Madrona Club in the subscription effort that paid for construction of their new building at Madrona Point. The land was donated by Drs. I. M. and Agnes Harrison.

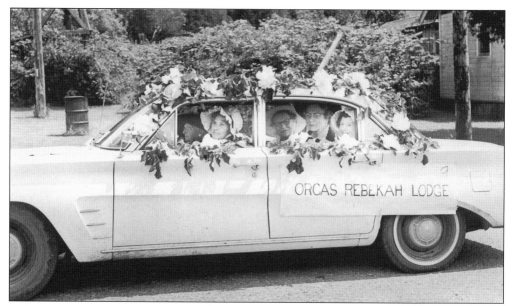

Lovely island blossoms peer from the carriage of the Orcas Rebekah Lodge in this photograph of the flower-bedecked conveyance in the Historical Days Parade. Island women, from early days on, have a strong tradition of mutual support expressed through social clubs and causes. The vagaries of island life, economic and otherwise, were often exaggerated by the distance between neighbors. Orcas Island women historically made it their business to see to the welfare of others.

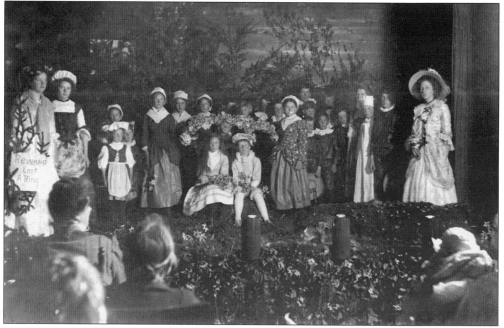

In 1910, teacher Nellie Sweeney stands with her class from the West Sound School at their performance of the school operetta. Parents and local residents, even those without children, customarily pitched in to help make costumes and decorations and assist in the school pageants and programs.

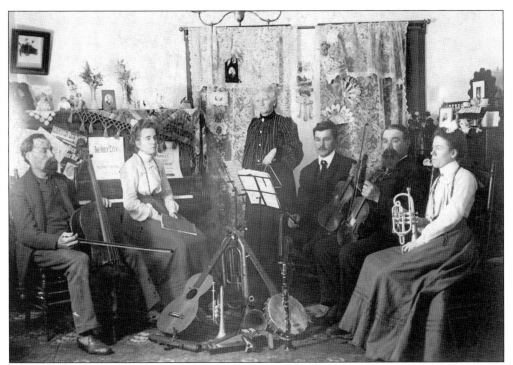

In 1908, sisters Rose Allison, on the piano, and Pearl Walrath, with her coronet, join these unidentified members of their community music group from West Sound.

In 1911, the West Sound Marine Band tunes up in the pasture, with Turtleback Mountain in the background. Members of all sizes and ages testify to the popularity of the band among the West Sound community.

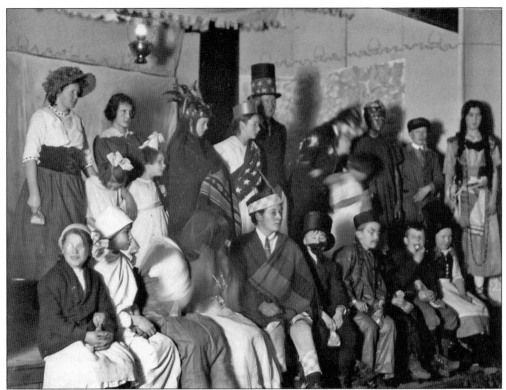

Granted a charter in 1891, the Orcas Island Odd Fellows Lodge has been a positive influence on the community for more than 100 years. The Christmas pageant, pictured here in 1914, was a typically well-attended affair.

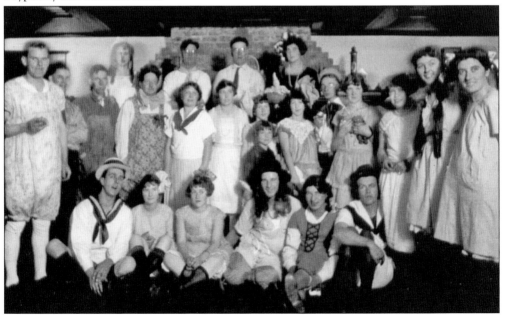

Orcas Islanders knew how to have fun, as shown in this December 1924 photograph of the "Kids Party" at the Virtues family residence.

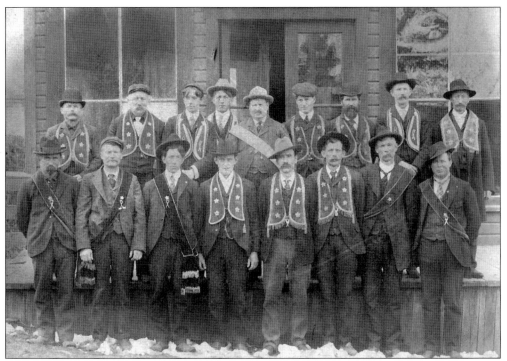

Island men took pride in their various fraternal organizations. Here Odd Fellows lodge members proudly pose in their regalia.

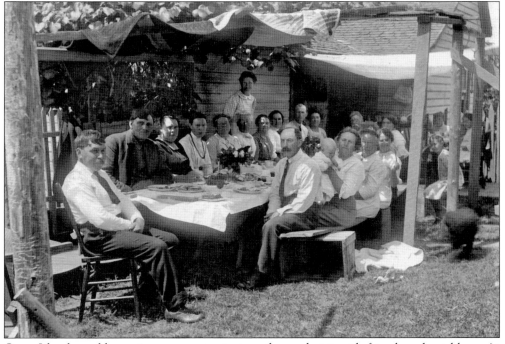

Orcas Islanders seldom miss an opportunity to gather and visit with friends and neighbors. At a party to honor Mr. and Mrs. King, a large group of well-dressed islanders, seated on chairs, planks, and boxes, surround tables setup under the arbor.

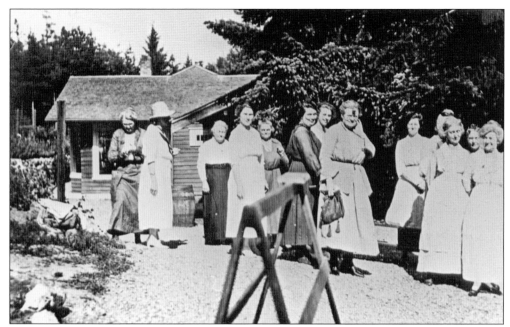

The Ladies Aid Society of Orcas Island was an important social force in its heyday. Members of the society gather for lunch in 1920 at Waldheim Resort near Eastsound.

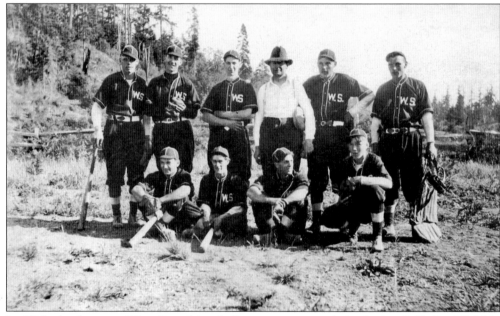

In 1915, the fearsome West Sound baseball team poses on their playing field. Fred Schieb, Clarence Ral, John Harrison, Johnny Sanders, Curley Cramer, Captain Jarvis, Howard Hall, Lawrence Schieb, Joe Schieb, and Walt Schieb all proudly wore the uniform of the West Sound team that year.

Orcas Island children enjoy snow as much as anyone, but see less of it due to the surprisingly mild island climate. The heavy snowfall of 1916 provided island youngsters with sledding opportunities they seldom had—although adults seemed to enjoy it as much as the children.

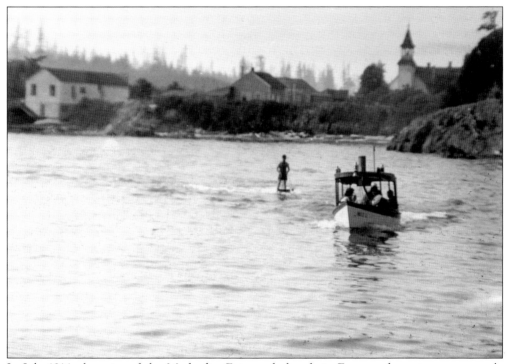

In July 1914, the spire of the Methodist Episcopal church in Eastsound towers over an early waterskiing excursion on East Sound Bay. The temperature of the saltwater surrounding the island "warms up" to only 52 degrees in the summer, leaving few islanders interested in risking immersion.

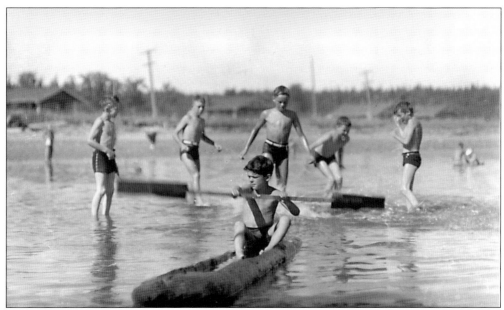

In August 1940, Don Gerard sets out in his homemade log canoe as unidentified boys frolic in the background of this photograph taken at Crescent Beach.

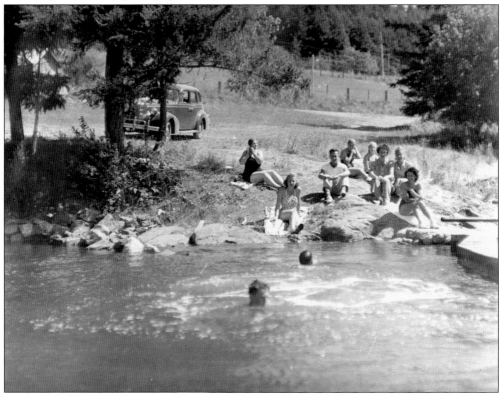

In August 1940, bathers, sun worshipers, and admirers gathered at the Norton Inn saltwater pool. The pool was popular with both guests and island residents, as swimmers did not have to battle the cold tidal currents, kelp, and flotsam found in the waters offshore.

Seven

ROBERT MORAN, ROSARIO, AND MORAN STATE PARK

Robert Moran, the son of Irish immigrants who first came to the northwest in 1875, was a wealthy shipbuilder and former mayor of Seattle who became Orcas Island's greatest benefactor. In 1904, he was in failing health and his doctors diagnosed heart disease in the wealthy and powerful Moran, predicting that he had less than a year to live. He disposed of his shipbuilding empire and retired to Newhall at Cascade Bay on Orcas Island, which he purchased from Andrew Newhall, the founder. He renamed the huge estate Rosario, after the strait between the San Juan Islands and the mainland, and set out to build a mansion at the scenic location in the few months left to him.

The healthful benefits of living on Orcas Island can perhaps best be attested to in the fact that the dying Moran lived for another 40 years, busily engaged in building roads, dams, water systems, yachts, and employing dozens of island men in various projects. For Olga, he built and donated the first public water supply on Orcas Island. He acquired over 2,600 acres of land, comprising virtually all of Mount Constitution, and donated it all to the State of Washington. As the first state park, Moran State Park remains one of the most popular in the state today.

Over the next 40 years, Moran spent more than $1 million on various construction projects, many for the use of the public, on Orcas Island. He built roads and donated them to the county, along with all the equipment used to build them, and he paid for the paving of the main road from the Orcas ferry landing to Eastsound. During the Depression, he was the single largest employer on the island, providing much-needed jobs to many island men.

Robert Moran passed away March 28, 1943, at the age of 86 years. His legacy on Orcas Island has not diminished with the passage of time and his generous gifts continue to be enjoyed by the thousands of people who come every year to stay at the Rosario Resort, his former home, or by those who camp, swim, hike, and sightsee in Moran State Park.

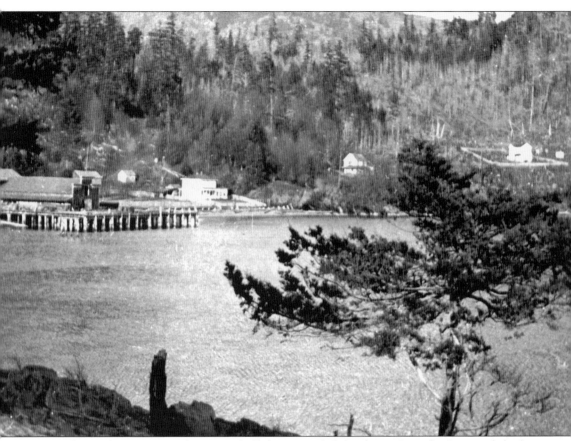

In the early 1870s, Andrew Newhall homesteaded land at Cascade Bay and built a thriving sawmill and boatyard at the settlement that came to be known as Newhall. His successful application for a post office helped secure a mail contract for his steamer, the SS *Buckeye*, which was later replaced by the SS *Islander*, a steamboat he built at the boatyard he founded at Newhall. The mail, passenger, and freight traffic between Whatcom and Newhall stimulated growth and commerce and Newhall became one of the first thriving settlements on Orcas Island.

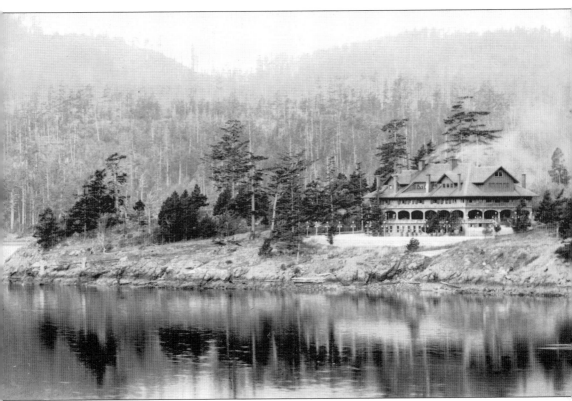

This is the mansion at Rosario, Robert Moran's estate at the former location of the community of Newhall on Cascade Bay, Orcas Island. Work on the mansion began in 1906, employed dozens of craftsmen, and was completed in 1909. Before beginning construction of the mansion, Moran built a log dam at Cascade Lake, 350 feet above Cascade Bay, to generate the waterpower needed to run the hydroelectric plant he designed and built to provide power for his shop motors. The hydroelectric power also generated power for lights, cooking, refrigeration, and laundry equipment. Rosario was one of the earliest homes to be completely heated by electricity. The first three levels of the mansion structure were built entirely of steel-reinforced concrete, 10 inches thick, while the top two floors were of frame construction. Lumber used in construction of the mansion was imported in whole logs, primarily Indian teak and Honduran mahogany, and was milled in the sawmill on site. All the bronze casting for door hardware and hinges was done on in a workshop on site. The floors of inlaid basket parquet, made from old growth fir trees, took craftsmen two years to complete. Windows of Belgian plateglass provide natural light and distinctive views. Moran allowed no pictures on the walls, preferring that nothing should compete with the views of the beautiful natural surroundings.

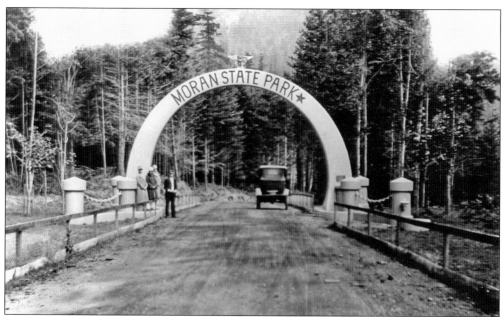

Perhaps the greatest legacy of Robert Moran is Moran State Park, which became the first state park in Washington. The initial gift of 2,998 acres to the state had to be declined, as the state at that time had no parks department and could not legally accept the gift. Moran persevered and the state finally accepted the offer in 1921. After dedication of the park as Moran State Park, Moran continued to build roads, trails, concrete bridges, and gateway arches at the north and south ends of the park.

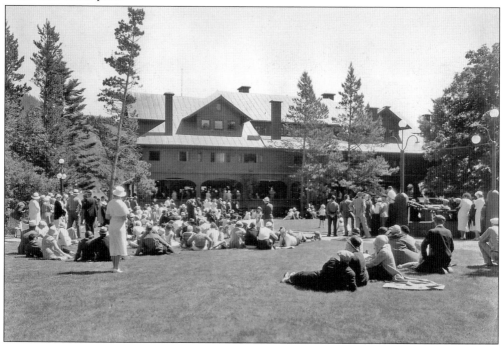

The dedication of the paved road to the top of Mount Constitution in Moran State Park was a major event in 1933, attracting hundreds of people to the Moran mansion at Rosario.

Robert Moran, at the far right in this 1933 photograph, stands with some Moran family members and visiting dignitaries high atop Mount Constitution for the road dedication.

This concrete and steel bridge on the road to Mountain Lake and Mount Constitution was designed and built by Robert Moran, after he had donated land for the first state park to the State of Washington.

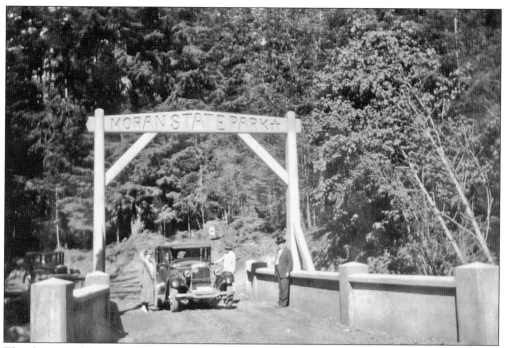

The driver and his passengers pose with their automobile under the south entrance arch to Moran State Park.

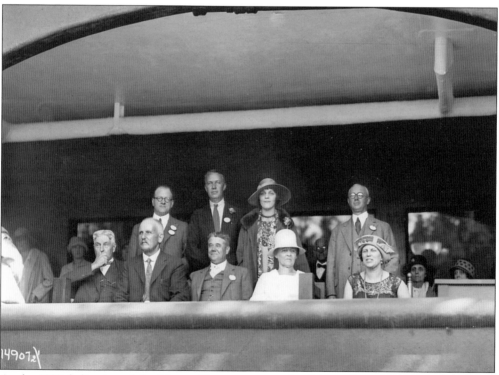

At the 1933 dedication of the Mount Constitution road in Moran State Park on Orcas Island, Robert Moran is seated second from the left.

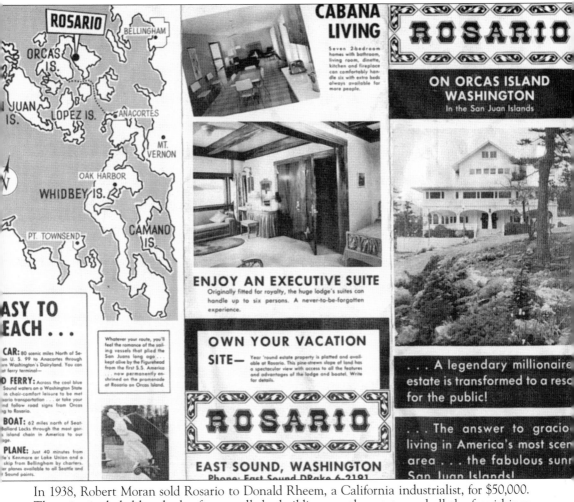

In 1938, Robert Moran sold Rosario to Donald Rheem, a California industrialist, for $50,000. The price included hundreds of acres, all the buildings on the estate, and all the furnishings in the mansion. Rheem had the property for some 20 years before selling it to Gilbert Geiser in June 1960. Geiser turned the private estate into a luxury resort offering "gracious living in America's most scenic area . . . the fabulous sunny San Juan Islands."

Civilian Conservation Corps (CCC) men worked under skilled local craftsmen, who taught the men to do everything from peeling logs to erecting stone chimneys. The quality of their work can easily be seen in the well-made log and cedar shake structure of Cold Springs Camp in Moran State Park.

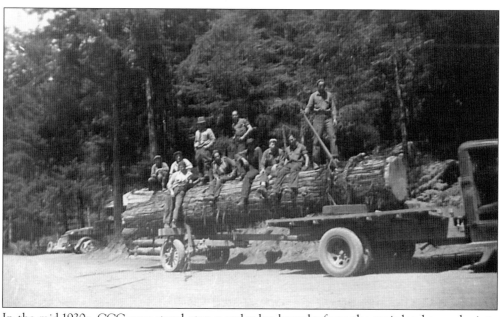

In the mid-1930s, CCC men stand atop a cedar log brought from the mainland to make into shakes for cabin roofs.

The footbridge over Rustic Falls on Cascade Creek in Moran State Park was constructed in the 1930s by CCC men during their stay on Orcas Island.

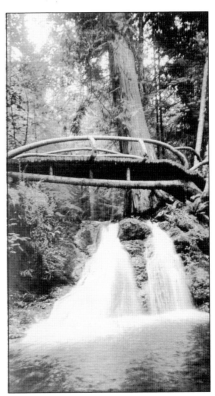

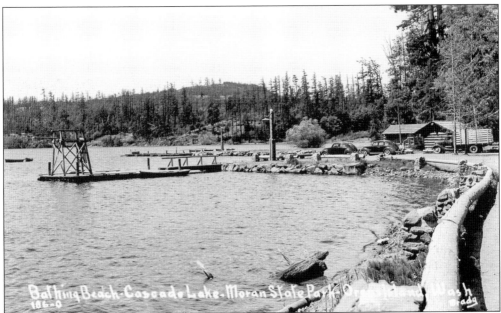

Orcas Islanders, wary at first and unaccustomed to the city ways of many of the CCC boys, quickly warmed to them and welcomed the products of their hard work in the park. From the labor of these young men, the swim area at Cascade Lake in Moran State Park was transformed into a modern bathing beach, complete with log buildings, dock, guardrails, and swimming floats.

Pictured here in 1936, the orderly room staff at the CCC camp, from left to right, is the company clerk, supply clerk, mess hall supervisor, and the first aid supervisor.

CCC recruit John B. Collins is engaged in important work—visiting with an island girl in front of Templin's Store in Eastsound on this trip in his army truck. Like young men everywhere, the CCC recruits quickly became acquainted with the local beauties, which did not always go over well with the local island men.

In 1935, John B. Collins joined the CCC just before his 17th birthday. From the Chicago area, as were most of the men in Company No. 1647, Collins was an army truck driver during his time at Camp Moran.

Recruit John B. Collins photographed these island girls when they came to visit the CCC camp, where dances were held, well attended by locals as well as the recruits. Pictured, from left to right, are (first row) Margie Nicol, Karla Templin, and Grace Evans; (second row) Eleanor Meredith and Georgina Templin.

In 1936, CCC Company No. 1267 arrived on Orcas Island at the Obstruction Pass dock.

Life at Camp Moran wasn't "all work and no play" for the CCC men. Recreational opportunities included baseball, basketball, boxing, pool, swimming, and volleyball.

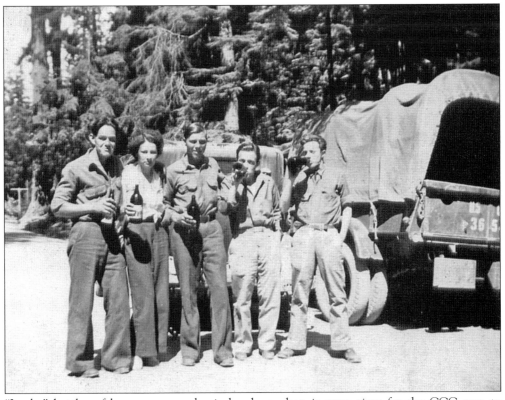

"Jumbo" bottles of beer were popular icebreakers when it came time for the CCC men to socialize with the island girls.

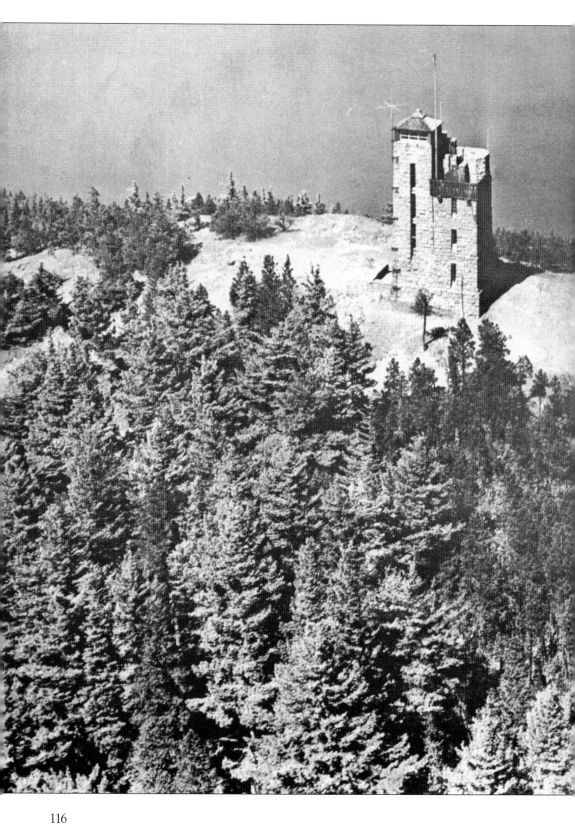

The crowning glory of Moran State Park is the Observation Tower at the summit of Mount Constitution. The tower was built by 28 CCC men under the direction of Seattle architect Ellsworth Storey, who modeled it after ancient watchtowers in the Caucasus Mountains of Eastern Europe. One thousand tons of native sandstone quarried on the north shore of Orcas Island was trucked by the CCC men to the summit of Mount Constitution for its construction, which took over a year. The tower provided the first unobstructed views to all points of the horizon. It offered shelter to the many people who came every year to see the incredible marine and mountain vistas and provided an observation station for firewatchers. The panorama, viewed from atop the tower, includes all of the San Juan Islands, the Canadian Gulf Islands, part of Vancouver Island, the Cascade Mountains, and the Olympic Mountains.

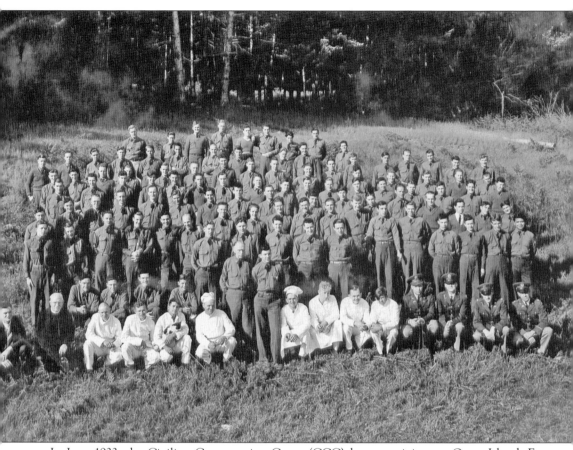

In June 1933, the Civilian Conservation Corps (CCC) began arriving on Orcas Island. For the next eight years, CCC crews came from as far away as Arkansas, Minnesota, New York, Missouri, Illinois, and Kansas to work at Camp Moran. One year after their arrival, the CCC had already developed over 10 miles of new trails including those around Mountain, Cascade, and Twin Lakes, completed a 60-foot fire trail completely around the park, improved 20 miles of existing trails, and upgraded nine miles of road. Here CCC Company No. 1647 poses with cooks, bakers, and army officers—uniformed and looking their best in this 1937 photograph. Camp Moran also operated a "spike" camp of 25 men who worked at the University of Washington laboratories on San Juan Island. The two camps had the distinction of being the only island CCC camps in the United States. Camp Moran closed in 1941, an event lamented in a local newspaper article of July 3, 1941, that stated, "the closing of Camp Moran is regretted by every citizen on the island . . . every effort has been made by Orcas Island people to keep the camp open, but apparently without success."

Eight

THE MODERN ERA

The early decades of the 20th century saw significant changes in life on Orcas Island, many spurred by improvements in communication, technology, and transportation services. The rise of scheduled automobile ferry service brought increased numbers of visitors and tourists to the island, and many wanted to stay for a night or a week. Moran State Park became a popular destination for campers, island resorts providing lodging for the tourists were a booming business, and the roads were gradually improved.

Resorts became the driving force of the Orcas Island economy in the years following World War I, with their clientele changing from the early vacationers accustomed to tent camping to those with a more modern lifestyle and expectations. Among these were the daily conveniences people had grown accustomed to in the cities and towns on the mainland, but which had formerly been missing or in scant supply on Orcas Island.

The Inter-Island Telephone Company first brought telephone service to Orcas Island in 1901, although it took many more years for the service to be available to all residents. By 1939, the telephone company still had only 175 subscribers on the entire island, all using hand-crank telephones on party lines connected through a single switchboard.

Electrical power was not widely available until 1938, when the Orcas Power and Light Company secured a Rural Electrification Agency (REA) loan of $120,000 for generators and 50 miles of distribution lines. A generating plant was constructed and by 1941, dependable electrical power had become available to subscribers island-wide.

In 1938, all Orcas Island school districts were finally consolidated and school buses provided transportation to Eastsound for all students, including those from nearby islands who commuted daily by boat to attend the high school.

Scheduled ferries operated by the Washington State Highway Department eliminated the previous vagaries in rates and service and increasing numbers of visitors reached Orcas Island every year. Dependable, scheduled air travel became available when Orcas Island Air Service, the first small commuter airline on the West Coast, began operating in 1947 from a dirt runway near Eastsound.

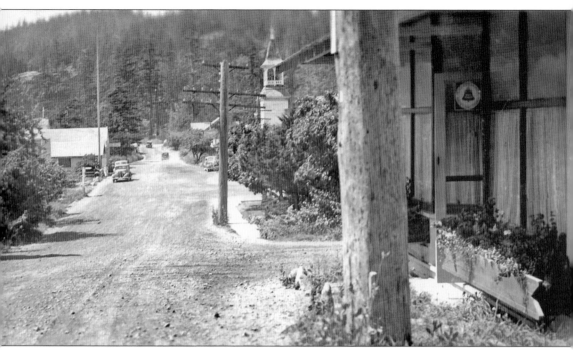

In 1901, Alfred Douglas and his Inter-Island Telephone Company brought telephone service to Orcas Island. The first service was available only to Deer Harbor residents, slowly extending to West Sound, Eastsound, and eventually to the entire island. The earliest subscribers had to string their own lines from their homes or businesses until they could connect to the main line. All the lines converged at the switchboard in the central office, seen here on Main Street in Eastsound. Operators worked eight-hour shifts, fielding all manner of questions from islanders calling on their hand-cranked telephones over the party lines. It wasn't unusual for an "eavesdropper" to suddenly, and embarrassingly, offer the answer to a neighbor's question.

The Inter-Island Telephone Company began service on Orcas Island in 1901, listing all subscribers in an alphabetical directory as the service became available to the entire island. When the telephone company changed from hand-crank to dial telephones in 1957, irate customers sent a 28-foot-long letter of protest to the company.

ALPHABETICAL LIST
OF SUBSCRIBERS

Inter-Island Telephone Co.
ALFRED DOUGLAS, Gen. Mgr.

Orcas Island Division
J. T. STROUD, Manager

Journal Print, Friday Harbor

This was the original office of Orcas Power and Light Cooperative, locally known as OPALCO. It still provides power to the island. In 1938, Orcas Island became the first community of its type to receive a loan from the Rural Electrification Agency. The original $120,000 loan paid for 50 miles of distribution line and two diesel generators.

ORCAS POWER & LIGHT CO.

Eber Bruns adjusts the speed control of the No. 5 generator in the completed Orcas Power and Light Cooperative plant. Bruns was the plant operator from 1939 until his retirement in 1967, and was said to be so familiar with the power generation equipment that he could detect problems by sound alone. In 1939, he and his wife, Altanta, moved to the plant site. He assisted in the construction of the building, supervised installation of the motors and generators, performed line repairs and service calls, and operated the plant and all its equipment. Working six days a week for $100 per month and free power, Bruns took such excellent care of the plant and equipment that, in the words of the manager, J. E. Harrison, "I can assure you that our record for upkeep and maintenance costs has been up for question by the various departments of the REA due to the fact that there seems to be no entries in these columns at all. I keep the books myself and, so help me, I never get a chance to make such entries except for an occasional bale of rags." According to the *Rural Electrification News* of November 1941, before REA, the power requirements of the various resorts, estates, and businesses on the island were supplied by "the most amazing collection of little generating plants to be found anywhere."

Eber Bruns, plant operator, poses in front of the nearly completed addition to the existing power plant. The motors and generators were barged to North Beach, then trucked to plant, a distance of two to three miles from the beach where the barges landed.

This December 1948 snowfall does not keep Eber Bruns from his work as plant operator, lineman, and general repair person for the Orcas Power and Light Cooperative.

Three young lovelies grace the Raymond Fire Department's fire truck, which became Orcas Island's first "real" fire truck in 1948 when Bob Schoen found it, arranged the purchase, and drove it to the island. Previous island fire trucks were homemade arrangements, one of which famously had to be garaged on a hill to ensure it could be started in the (usual) event the battery was dead. Upon reaching Orcas Island, Schoen is reputed to have remarked that he had nearly drowned driving the truck in pouring rain all the way from Raymond to the Anacortes ferry landing, a distance of more than 100 miles.

The Orcas Island Fire Fighting Service, pictured atop a 1936 Dodge truck borrowed from Bill Keel's parents, from left to right, are Jim Lavender, Roy Reddick, Nova Langell, Jack Coffelt, Bill Keel, Tom Lavender, and fire warden Jack Anthony. The State of Washington paid these forest firefighters, providing each of the younger men $130 per month.

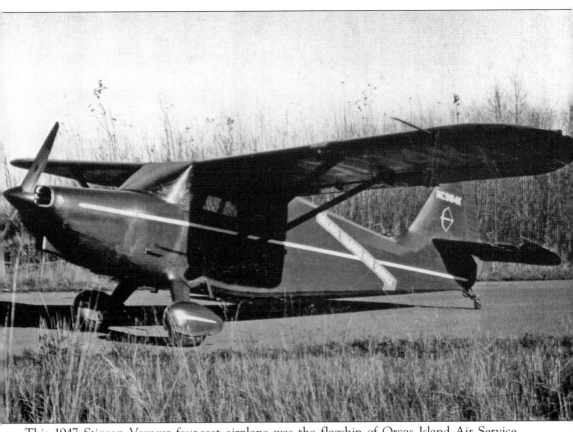

This 1947 Stinson Voyager four-seat airplane was the flagship of Orcas Island Air Service, started in July 1947 by Bob Schoen as the first small commuter airline on the West Coast. Orcas Islanders had long desired a faster means of transport to Bellingham, the nearest mainland city, for shopping, medical care, and social visits, and Schoen's new airline quickly became popular. Roy Franklin, a veteran pilot instructor, joined Schoen in 1948 shortly after he changed the name of the airline to Island Sky Ferries. Schoen and Franklin were the pilots, while their wives, Mary Schoen and Margaret Franklin, ran the office and handled reservations. Two trips were flown daily between Orcas, San Juan and Lopez Islands, and Bellingham. The airline would stop at Waldron Island only if the local agent raised a flag, alerting the pilot there was a passenger waiting. All of the island airstrips at this time were private affairs with wildly variable runways—short, rough, or narrow—and no lights or other equipment except for a windsock. It wasn't unusual for them to have to "buzz" an airfield before landing to scare the deer off, and more than one rabbit met an unfortunate end under the landing wheels. For emergency night flights, the airfield owner would place old highway flares (steel containers with wicks burning diesel oil) along the left side of the runway to guide the pilot. In 1950, Island Sky Ferries was sold to Dr. Wallace Howarth, a San Juan Island resident. During the three years Island Sky Ferries operated under Schoen's ownership, inclement weather prevented the pilots from flying on only 10 days. To anyone familiar with local weather in the winter months, when rain, fog, and mist make visibility difficult even at sea level, the skill and courage of Roy Franklin and Bob Schoen is remarkable.

Bob Schoen provided safe, economical transportation in a novel fashion, and Orcas Islanders quickly grew to depend upon the Orcas Island Air Service. To make a reservation, one could reach the airline by dial phone or the more common crank phone (3X means three rings or three cranks on the handle), or simply show up at the airport. A roundtrip flight to Bellingham from Eastsound cost $7, as shown, and saved many hours spent riding the ferry or boating to Bellingham from the island.

BIBLIOGRAPHY

Keith, Gordon. *The James Francis Tulloch Diary 1875–1910*. Portland, OR: Binford and Mort, 1978.

McLachlan, Edith. *They Named it Deer Harbor*. Concrete, WA: Concrete Herald Publishing Company, 1972.

Peacock, Christopher M. *Rosario Yesterdays*. Eastsound, WA: Rosario Productions, 1985.

Richardson, David. *Pig War Islands*. Eastsound, WA: Orcas Publishing Company, 1971.

Splitstone, Fred John. *Orcas, Gem of the San Juans*. Eastsound, WA: Fred T. Darvill, Second Edition, 1954.

Tillman, Thomas T. *Timeline of Orcas Island History*. Olga, WA.

DISCOVER THOUSANDS OF LOCAL HISTORY BOOKS
FEATURING MILLIONS OF VINTAGE IMAGES

Arcadia Publishing, the leading local history publisher in the United States, is committed to making history accessible and meaningful through publishing books that celebrate and preserve the heritage of America's people and places.

Find more books like this at
www.arcadiapublishing.com

Search for your hometown history, your old stomping grounds, and even your favorite sports team.